Roy Arden

IKON

Foreword

This is the first major survey exhibition of work by Canadian artist Roy Arden in Europe, comprising photographic and video works from 1985 – 2005. Born in Vancouver, Arden has been a key member of a generation of artists who established this city as an important centre for contemporary art. Practising a distinct realism he takes subject matter from his immediate environment, with its very particular social history and development, to touch on issues of global significance, increasingly urgent as we proceed into the 21st century. Arden's proposition is as poetic as it is political, against the kinds of greed and injustice that give consumer capitalism a bad name, forming the basis of an extraordinarily rich body of work, at once disturbing and visually compelling.

A photographic image constitutes a trace of something that once actually happened, and this is key to the strength of Arden's work. Early pieces here, including *Rupture* and *Abjection*, involve archival imagery depicting individuals marginalised by historical circumstances – unemployed workers and Japanese prisoners of war, respectively – and the recent video *Supernatural*, similarly is based on readymade pictures. The latter is derived from TV news footage of a hockey riot, not the answer to a question of life and death ostensibly, but equally symptomatic of malaise. Photographs of rubbish on the streets and neglected objects in storage, seen here with others featuring "pile-them-high" shop displays, and pictures of so-called *Monster Houses* seen in the context of searing land clearance, raise poignant ecological questions. Arden's images provide hard evidence of overproduction and needless waste, thoughtlessness in the light of what common sense tells about the limited availability of natural resources. Other recent videos, *Citizen* and *Juggernaut* likewise are critiques of the way we live now, amazingly powerful through an aesthetic stringency that demonstrates the artist's smart grasp of his medium.

As we acknowledge the privilege of having this exhibition at Ikon, we take the opportunity to thank those individuals and organisations without whom it could not have happened. His Excellency, the Canadian High Commissioner, Mel Cappe and Michael Regan at Canada House, London, and David Birch, Canadian

Honorary Consul, Birmingham, have been supportive from the first, wonderfully sympathetic to the nature of our activity. Yves Pepin and others, at the Canadian Department for Foreign Affairs and International Trade (DFAIT), and colleagues at The Vancouver Art Gallery, Kathleen Bartels and Daina Augaitis, also could not have been more helpful.

The support of Nigel Godfrey and Parvez Pirzda has proved invaluable in realising the presentation of *Citizen* off-site. Thanks to Monte Clark and to the various lenders, unstinting in their generosity – Jeremy Caddy, Wilhelm Schürmann, Jeff Wall, the Canadian Museum of Contemporary Photography, Oakville Galleries, Galerie Tanit and Vancouver Art Gallery. Special thanks also to Tahina Awan and Daniel Faria for their practical assistance. Above all, our thanks to the artist for his remarkable vision.

Jonathan Watkins
Director

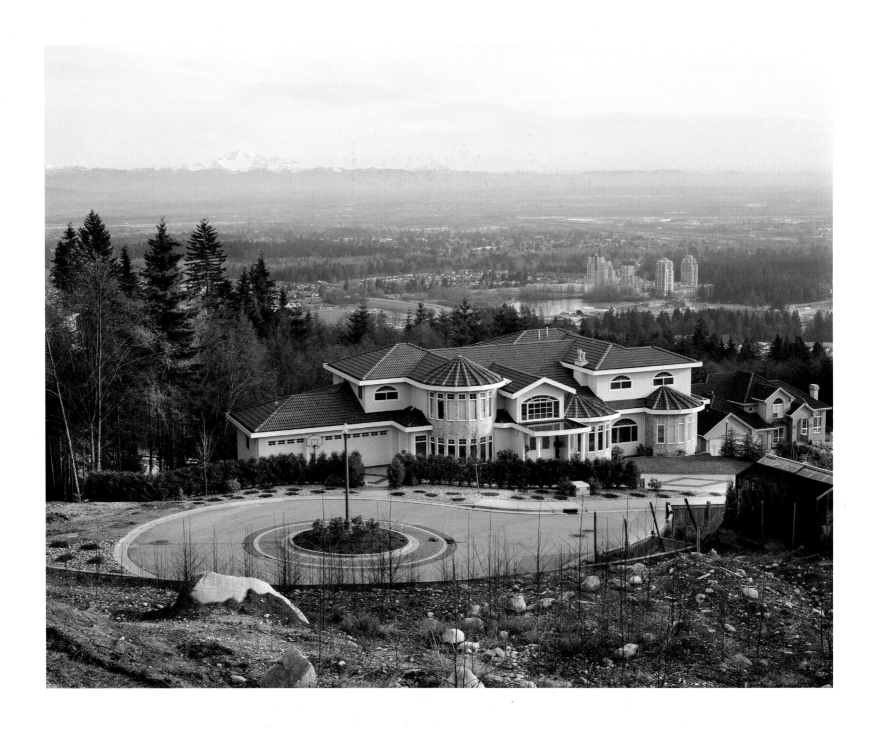

'Monster House' Coquitlam, B.C. 1996

Roy Arden – Imagining the Real

Nancy Tousley

The story begins right at the bottom of the picture, where the shallow foreground of dirt, weeds and scattered debris is cut off by the top of a retaining wall, the raw edge of new development. From there the ground falls away precipitously and the eye lands in a cul-de-sac. A suburban street ends here in a concrete loop with new plantings and an old-fashioned lamppost in the centre. Beyond and slightly lower down the slope, all but filling the near view, sits the huge, white, steeply perched *Monster House, Coquitlam, B.C.* – a turreted folly with a basketball hoop attached to its three-car garage – that is the ostensible subject of Roy Arden's 1996 colour photograph.

Beyond the house, its neighbour and the fir trees behind, a panoramic vista unfolds in deep focus like one of those 17th-century Dutch landscape paintings that appear to map the world. The middle distance of the photograph opens over the vast Fraser Valley. Tall, white apartment towers rise up on the right, like a phantasmagoria at the edge of a lake. The suburban forest stretches as far as the eye can see into a pollution-tinged band of atmospheric haze. Towering above it all on the left, from across the border with the United States, is Mt. Baker's distantly visible, mirage-like, snowcapped peak.

The eye finally settles here, but it's the trip back that is important. Retracing the zigzagging diagonals of this complex composition re-establishes the link between the mountain pinnacle and the debris-strewn dirt of the foreground. It's in this direction that the descriptive narrative of Arden's photograph moves: from top to bottom or back to front, towards the picture plane and the viewer. The space travelled has social meaning and allegorical meaning, as well. To go from the highest to the lowest point in the picture is to move conceptually from an iconic image of the sublime in nature to an abject remnant of the natural. It is to move from an indistinct pictorialist ideal to a focused, realistic image of everyday life.

The passage across the image reads like the allegory of a fall presented with the matter-of-factness of Bruegel's *The Fall of Icarus*. But in fact the work's internal

movement takes us in both directions, rising and falling, endlessly circulating on a vertical axis: between the elevated and the base, the high and the low.

Positioned between these dialectical poles, the "monster house" represents a historical moment, one in which the driving forces of society and history are busily shaping what Arden terms "the landscape of the economy". The balloon-frame monster house, an architectural type purpose-built to move foreign capital out of Hong Kong into Canada, is a recent Vancouver phenomenon. It is also a symbol of globalisation, as well as of class. The landscape it inhabits is, likewise, at once actual and theoretical: the city of Greater Vancouver and, to borrow art historian T. J. Clark's phrase, the city as "a sign of capital."

Arden maps one city onto the other in a body of work that encompasses Vancouver's violent past and its forgetful present: the old, decaying, working-class neighbourhoods and the burgeoning suburban developments; the discount stores stocked with obsolescent goods and the growing landfills; the pockets of repressed wildness returning to the city and the receding natural world, uprooted and consumed by urban expansion. He takes his photographs on the derelict periphery of the downtown area, at the city's edges, in the industrialised margins that separate city and countryside, along the railway tracks and in the gutters.

It is in places like these, wherein all modern cities look the same, that the dynamics of change in late capitalism and the attendant entropy manifest themselves. Constantly in action, in and upon the landscape, these socio-economic forces leave their marks on the everyday in the overlooked, the unsightly and the formless. Arden's photographs render these forces visible, intelligible. Driving the city in his car, he scouts locations in which to construct photographs that reveal the abstract operations of the economy.

One could say that taken as a whole Arden's work is about modernity as a continuing process, mapped on capitalism, its engine, whose history begins at roughly the same time as that of photography. Moreover, his photographs are framed conceptually by the traditions of painting, and by the nature, history and genres of camera work, including film. Over two decades, his practice has encompassed what could appear to be disparate bodies of work. However, Arden's concerns, though presented in diverse forms, have been remarkably consistent. They are also deeply seated, influenced not only by his teachers and their interest in

the city as a subject (something that is shared among the Vancouver photo-artists, of whom he is a younger member), but also by his upbringing.

Arden is the son of Finnish socialists who emigrated to Canada from a country exhausted by the Second World War, into which his father had been conscripted as a boy soldier. Because of his parents' experience, he says, "I realised I lived in history and if you don't pay attention, it will grab you from behind." Arden arrived in Canada in utero in 1957 and was born in Vancouver that October. He grew up on a noisy street in a blue-collar neighbourhood in East Vancouver, just across from industrial sites that lined the banks of the Fraser River. He went to high school with the Kwakwaka'wakw Nation carver Beau Dick: "Observing him at work, I learned what culture is," Arden says. Later on, in the late 1970s and early 1980s, after studying religion and art history at Langara College, he studied at the Vancouver School of Art (now the Emily Carr Institute of Art and Design) with Ian Wallace. He completed a Master's degree in 1990 at the University of British Columbia, under Jeff Wall.

Arden describes the "landscape of the economy" project as "an attempt to register the transformative effects of modernity." This might also be posed as the question – why are things the way they are? – that has driven his career. Several leitmotifs emerge from the work and, perhaps more importantly for an understanding of Arden's process, it becomes clear that each series of work has sprung from ideas about realism and montage that form the base of his practice.

In the digital, post-photography era, Arden remains committed to so-called straight photography, made with an evident awareness of film, television, advertising and the history of painting. His images are not staged, either on a set or in a computer extension of the darkroom. The fact that they stem directly from his experience is a philosophical matter: the model for his practice is reportage. By choosing this model, he acknowledges the influence of Walter Benjamin and Georg Lukács, the Marxist literary critic, Atget and his German contemporary Heinrich Zille, Walker Evans and, of course, Wall, whom Arden credits with restoring credibility to realist photography after the critiques of the 1970s and 1980s. Wall has theorised Arden's work as photojournalism as art, while Arden's "reportage" underlines his active investigative stance, the sociopolitical content of his work and the relationship of the photograph as text to language.

"The lens is given the task of making discoveries," asserts Benjamin, who cites as the initial "discovery" Nadar's photographs of the Paris sewers, the first ever taken underground with artificial light. "With Atget," Benjamin writes, "photographs become standard evidence for historical occurrences, and acquire a hidden political significance." Like Evans, for whom Atget was also an early model, Arden works within this tradition. Moreover, in the ways that he constructs a picture that he "finds," one can see an equivalent of "the conceptual disclosure and presentation of causes and inter-connections" that, Lukács wrote, were for reportage the only sources of concreteness.

As it applies to Arden, then, reportage is a term that specifies that the photograph and its realism *are* constructions. Reportage first discovers and then exposes, both technically and figuratively, not only the telling incident but also its interconnectedness with broader meanings. "Finding" a picture is not so easy as it might seem, nor are Arden's photographs transparent. Their allusions peel back in layers: in a colour, a time of day, a quality of light, a compositional reference, an image that recalls a photographer, a painter or a writer. Their interconnections are achieved by variations on the concept of montage, which, as the photographer Alfred Kemény wrote in the 1930s, presents "opportunities – with regard to content, not just form – for uncovering *relationships, oppositions, transitions, and intersections of social reality."*

One of Arden's compositional strategies parallels camera movement in film. At the same time that *Monster House* is inescapably related to 17th-century Dutch landscape painting, its structure can also be read in relation to a film sequence that moves from a foreground close-up to a medium shot to a long shot in deep focus, the last a hallmark of Neo-realist film. Indeed, Arden, who earned his living as a projectionist in repertory film houses while studying art in the 1970s, acknowledges the Neo-realist film director Pier Paolo Pasolini as an inspiration.

A similar suggestion of filmic movement is also used in *Basement* (1996), a single work comprising twenty photographs, ten in black-and-white and ten in colour, shot in long, medium and close-up views. This work is also a serial montage, a sequential form that uses juxtaposition and contradiction to call forth the inter-connections among images, as well as the disjunctions or breaks between them. Echoing Nadar in the sewers, Arden "discovers" in *Basement,* which is flash-lit like

an exposé, an image of the city's unconscious in the waste of overproduction and entropy.

With regard to "uncovering," however, it is Surrealism, filtered through the writing of Georges Bataille, the dark philosopher of the *informe*, and the startling, grotesque photographs of the German-born Parisian artist Wols, that paradoxically has had the profoundest effect on Arden's realism. For Bataille, photography functioned as the "base evidence" of his theory of base materialism, in which the abject or ignoble disrupts the vertical social hierarchy with its power to erupt from below: photography bears witness to "the lowest of the low."

In Arden's work, this idea performs a double function. On the one hand, it brings to the archival photographs in his appropriation works of the mid-'80s the sign of the Freudian repressed, as in vertical montages like *Rupture.* On the other hand, in the everyday "landscape of the economy," it calls upon photography's indexical trace to testify to the presence of the abject, the *informe,* the uncanny and the need to expel the other at the unstable base of the capitalist superstructure. The base evidence, in each case, whether historical or contemporary, uncovers the city of the unconscious and its repression of what it cannot acknowledge.

Arden's reading of Bataille is visible from the start in "Fragments," a group of colour photographs made between 1981 and 1985 that he considers his first mature body of work. These lush, colour-saturated pictures were made when Arden was in his 20s. As seen now, they present as serial montage a lyrical, Joycean portrait of the artist as a young man. The portrait touches upon his milieu of poet and artist friends, his travels to Geneva, Berlin and Paris, and also his formation as a photographer. In the first photograph of the group, a self-portrait, Arden bends over his Rolleiflex on its tripod, with his sports jacket pulled over his head in the manner of a 19th-century photographer's black cloth.

This allusion to the black cloth; the pictures of shop windows, discarded chairs, antique clocks and architectural subjects; and the overall sense given by these Symbolist photographs of a flâneur's pleasure in the city streets point to Baudelaire's concept of the "painter of modern life," to Atget as practitioner and to Benjamin as modernity's philosopher. The European city of the flâneur is conflated with Vancouver. In the punning *Life Magazines (#1), Vancouver*, lies a reference to photojournalism; in *Pruned Trees (#1), Vancouver*, to violent Wolsian light and the

arboreal subjects of Wols' tachiste paintings. The latter foreshadows the livid, uprooted *Tree Stump, Nanaimo, B.C.* (1991). The "Fragments" of stained floors, peeling façades, derelict public men's toilets and water-filled gutters, the beginnings of an exploration of the *informe* that culminates in the mordant series "Terminal City," take Arden deeper into Bataille's neighbourhood.

By 1985, Arden had finished with the personal poetics of "Fragments" and began to make works using photographs from local civic archives as his point of departure. The shift in method, from originator of images to appropriator, signaled his move from a personal to an historical poetic.

The photographs of blue sky that comprise the top half of the nine vertical diptychs of *Rupture* might refer at once to the "bright blueness" in Bataille's novel *Blue of Noon,* symbolic of the continuity of Being, and to Benjamin's "time of the now." Below this realm, exerting pressure on the dividing line, are images of struggle and suffering. These are archival newspaper photographs taken in Vancouver on Bloody Sunday in June 1938. On that day, police quelled a protest by single, unemployed, homeless men, who, to qualify for relief, had to live outside the city in Unemployment Relief Camps. They were seeking their right to return to the city and work. Tear-gassed and beaten, the men literally are put down, into the gutter and the street.

In the editing, cropping and sequencing of *Rupture,* Arden, with allusions to Masaccio's *Expulsion From the Garden of Eden* and George Grosz's bandaged soldiers, portrays class warfare, returning the repressed memory to the city that has forgotten it. Overhead, the blue sky is marked by the lens, the camera's witnessing eye. The idea of the photographic archive as a vast compilation from which repressed history can be retrieved is expressed again in *Abjection* (1985). In this set of ten vertical panels, the archival newspaper photographs are from 1942, of Japanese men at a muddy fairground, where they have been forced to turn in their vehicles before being banished from the coast to internment camps. Above these images Arden has placed black squares of exposed photo paper. These photo-mono-chromes can again be read as signifiers of a transcendent sublime beyond the historical fact of the scenes below.

The notion of the archive, then, contains the possibility of recovering the evidence of many such events. *Rupture* and *Abjection* are a kind of "history painting"

that inverts the elevation of a cleansed cultural memory. In 1990, when he started work on the "landscape of the economy," Arden completed ten serial montages based on otherness, banishment and abjection. Nine years later, he revisits these ideas in the context of the "landscape" work in "Terminal City", for on the other side of the coin, fresh evidence can and must be added to the archive.

This discrete series of sixteen black-and-white photographs leads cinematically down a rock-strewn path, across the tracks, past 19th-century working-class houses surrounded by vegetation, to heaps of trash, lean-tos, mattresses and nests of rags and refuse in the woods. The camera, which begins with a long establishing shot, moves in steadily, tracking along a horizontal axis. The last three photographs are extreme close-ups, one of a battered death's-head of a typewriter, and two that fuse the abject and the *informe* in muddy, oil-soaked earth pocked with water-filled footprints and littered with used condoms. Although without people, this view is not only of the city's margins but also of the marginalised, akin to Atget's album of the "Zoniers," to Marx's lumpenproletariat, to Bataille's "lowest of the low."

Arden has not often photographed people. There are the portraits in "Fragments"; the solitary man walking on *Cordova Street, Vancouver, B.C.* (1995), an anomic inversion of the flâneur who looks like a character from a Jeff Wall; and the men at the strike hut in *'Locked-Out' Workers, Vancouver, B.C.* (1994). However, the focus of Arden's first video is a young man, sitting marooned with his belongings in the encircling traffic, like a figure out of Caravaggio or Goya, on a concrete island. Arden shot *Citizen* (2000) from a car, moving around the man and holding him in the viewfinder until, aware of the camcorder, the man turns his head to make eye contact before continuing the arc of his own gaze.

At this eureka moment, the citizen, caught by the camera halfway between an upright posture and the horizontality of sleep and death, is transformed by his own action from an object into a subject who is capable of enacting change. When this happens, it seems the actualisation of what Arden always looks for with his camera: the metaphor, the allegory, the validation of art that is present in the real.

This is a revised version of the essay *Roy Arden, Photographer*, originally published in *Canadian Art*, vol. 19, no.2, Toronto, Summer 2002

Terminal City (#4) 1999

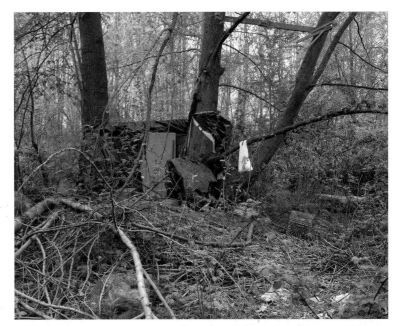

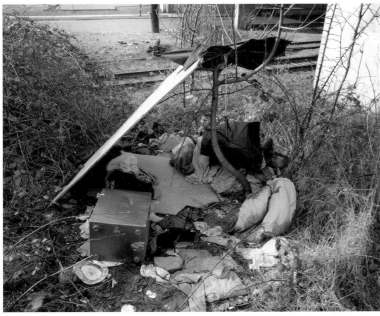

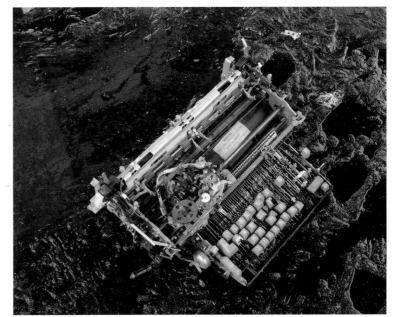

Terminal City (#5) 1999

Terminal City (#6) 1999

Terminal City (#10) 1999

Terminal City (#14) 1999

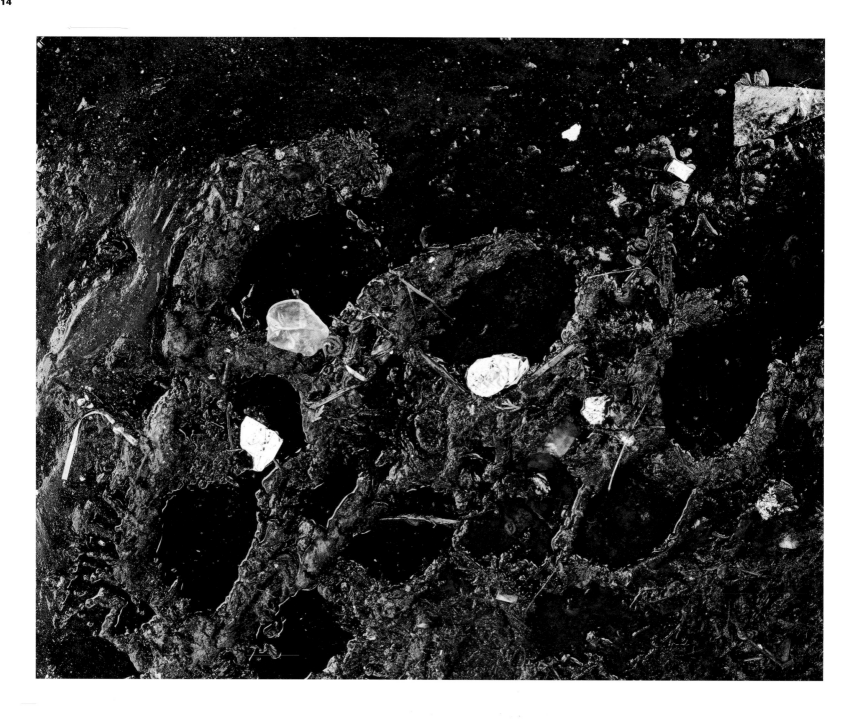

Terminal City (#15) 1999

Negative Diagnostics
Vision and Discontent in the Work of Roy Arden

Dieter Roelstraete

The history of the art of Vancouver since the mid 1980s is that of a return to the art of picture-making after a deluge of Conceptual Art injunctions. This however does not seek to restore the relative innocence of pre-conceptual art-making, but instead strives to mobilise the tremendous riches of Conceptual Art's many momentous insights in the service of a 'better', greater art; one that once again revolves around the event of vision.

In some sense, Roy Arden's artistic practice could be regarded as the nodal point in which the particularisms and peculiarities of Vancouver's response to the master narrative of Conceptual Art symbolically converge. His early 'archival' works clearly speak of the "fear of images" that has haunted the conceptual art movement since its inception during the critique of the spectacle that animated much of the sixties' culture of dissent. In both images collectively known as *Landscape of the Economy* and *Terminal City*, arguably Roy Arden's best-known works – and most widely discussed[1] – the artist has produced the harrowingly beautiful, sometimes even idyllic pictures[2] that seem to fly in the face of Conceptual Art's austere admonitions of anti-visuality. Works such as *Gutter with Rags*, *d'Elegance*, *Crow* and the various "stations" that make up the black-and-white *Terminal City* suite[3] are, quite simply, beautiful in all the ways that the first generation of conceptual artists perhaps sought to escape, for both political and philosophical reasons: they are richly textured, well-crafted in tone and lighting, graciously and studiedly/ purposefully composed; they are alive with art-historical and cultural references ranging from Bataille and Wols to Smithson and Nadar. Swinging back and forth between the symbolic extremes of "appropriation" as a way of accommodating the staunch minimalist and anti-pictorialist injunctions of Conceptual Art, and the defiant creation, *ex nihilo*, of lush photographic tableaux that usher in a return to the pictorialist endeavour in general, the work of Roy Arden in some way re-enacts the great culture wars of late twentieth-century art. In addition, this apparent

ambivalence or duality is also reinstated in Jeff Wall's astute characterisation of Arden's photographic practice as one that "halts at the threshold", which divides the realm of the autonomous pictures dotting the new Salons – most consciously represented by Andreas Gursky and Thomas Struth – from "the poetic utilitarianism mapped out by Dan Graham and his photojournalistic precursors". According to Wall's scheme, Arden's photos of car wrecks, tree stumps, soil compactors, dismembered typewriters and boarded-up houses "hover just at the point of resembling autonomous works of pictorial art. They reflect both the moment at which photojournalism becomes art, and the last one in which it remains lyric, miniature, and utilitarian – that is, in which it remains *reportage*."[4]

Arden's early 'archival' works, such as *Rupture*, *Abjection* and *Mission*, all dating from the mid-eighties, the photographic brand of "appropriation art" to which these works so subtly nod[5], speak of the fear of image-production instilled in a generation of artists raised on Conceptual Art's forbidding doxa/orthodoxy/glory/honour of anti-visuality and anti-pictorialism; they show the artist engaged in a battle with the formidable question of what it means to make pictures. Momentarily spellbound by this punitive prohibition to make pictures, Arden abandoned the sensuous innocence and diaristic lyricism of his early photographic works, *Fragments*, "the balmy pre-Expo provincial enclave (…) in which young artists could apparently discover and describe the city and its inhabitants as if for the first time", as Peter Culley would have it[6] and turned to the city archives as a repository of already existing images. Here, he subsequently unearthed a whole series of news photographs documenting the violent suppression of Vancouver's 1938 labour riots[7] among others, and his work took a decisive turn towards a more detached, understated and coolly registering (objective) diagnostic mode. It should come as no surprise that this turn towards the diagnostic was marked by Arden's picking images of *defeat*; the slightly *défaitiste*, melancholy mood of the artist's retreat from "making pictures" and subsequent adoption of a stoic appropriationist stance, is echoed in a balanced selection of pictures from an era called the Depression and dwelling on catastrophic events of abjection, rejection, repression and denial.

For *Rupture*, Arden selected nine archival photographs of these riots – the documentary value and purpose of which was obviously obfuscated by the very act of appropriation or (as in *Abjection* and *Mission*) the application of less-than-standard

cropping methods – and complemented each of these images, rather polemically, with a single shot, taken by the artist himself, of a cloudless, deep-blue sky to arrive at a series of nine vertically arranged diptychs. It is quite telling, that the photographs of a blissfully sunlit sky should have been the only images the artist felt entitled or empowered to make in the face of the terrible, unrepresentable traumas that History inflicts on the luckless lower classes. Indeed, these images belong to the long (and, as of yet, largely unwritten) history of the monochrome as the purported site of erasure, oblivion and renewal, and to the history of negation as a negation of history.[8]

In *Abjection*, comprising ten photographic diptychs that document the wartime internment of Canadian Citizens of Japanese origin, the upbeat, absolving mono-chromatic blue has been replaced with a simple black square, an image that is of course replete with 20th century art historical references, and the negating power of which is far less ambivalently posited than that of the blue skies'. Furthermore, the black squares in *Abjection* offer an even more radical dramatisation of the artist's powerlessness and/or refusal to make pictures in the face of catastrophe: these squares are no longer even pictures, but mere sheets of exposed photographic paper symbolising the very annulment of all acts of picture-making as image-production, and the renunciation of all complicity in the production of spectacle as such. In *Mission*, a photographic diptych depicting the sorry sight of the evangelisation of British Columbia's native peoples around the turn of the century, this bleak idea of the monochrome ultimately returns as a mural, i.e. the blood-red backdrop to the actual archival photographs fitted in featureless black frames; this work represents appropriation at its very zenith, reducing the artist's actual powers of intervention to a mere framing operation – or iconophobia at its very nadir.

Taken together, then, the archival works that duly cemented Arden's reputation as an avid, conscientious chronicler of Vancouver's subterranean, all too easily forgotten histories of anomie and discontent – his understanding of the dialectical forces that have shaped the fate of Vancouver and British Columbia in general (as they have done with so many other places all around the world) singles him out as the artist-historian *par excellence* in a city famed for its historically aware artists. Many of whom were in fact trained as art historians[9], and most acutely and forcefully embody this fearful suspicion of the uncomplicated image in the hegemonic regimes

of modern visuality. In his laconic refusal of, or withdrawal from, the order of the visual – his declination of the artist's "right" (or, in a more romantic-messianic mode, "duty") to produce imagery on art's own, tradition-sanctioned terms, Arden's stance speaks of fear (of the image's political impact), distrust (of the image's politically manipulative uses), rejection (of the image's political futility) and of a sobering realisation of the powerlessness inherent in all arts of image-making. Similarly, these experiences are also what Arden's archival works seek to capture and register in their various memoirs of misery. Together, they set the tone in which the voice of history's ruthless logic continues to address the world.

Supernatural is the artist's first-ever moving-image piece consisting entirely of archival footage. Shot by local news stations it depicts the so-called "hockey riots" that tore up Vancouver's usually peaceful, gentrified downtown shopping district sometime in the summer of 1994 after yet another humbling defeat for the under-achieving local hockey team, the Vancouver Canucks. In this work, Arden revisits both the archive as atelier or image bank from which the artist, as an amateur archaeologist, distils the raw material of Art, and Vancouver's local history as an unlikely cauldron of social unrest, subversion and discontent.

The images in *Supernatural* clearly resonate with the potent memory of *Rupture*, the work that perhaps most succinctly signalled the advent of a contemporary master, in that they both serve up iconic images of proletarian strife and the State's subsequent violent response to it. In terms of content, however – that, is in terms of these images' respective political meanings – these works could not be further apart in that they effectively portray two very different types of civil unrest, or two types of societal antagonism with very different raisons d'être. Whereas the downtrodden masses in *Rupture* are actively engaged in a righteous revolutionary struggle for Bread and Work – the classic stuff of socialist legend, as this is New Deal-era, thirties America/Canada, the epic age of Walker Evans' *Let Us Now Praise Famous Men* – the unruly mob in *Supernatural* are no longer masses or even multitudes in need or search of jobs or food. Rather they are wreaking havoc just for the dismal fun of it, and thus incarnate the lumpen residue of irreducible Bataillan excess that no social system, however secure, tightly controlled or sensibly accommodating, will ever succeed in containing – the reptilian yearning for cathartic release through random acts of preferably 'stupid' violence and silly transgressions.

It is impossible to gloss over the glum political commentary that is insinuated in Arden's implicit coupling of *Supernatural* with *Rupture* as a document of the sorry fate that has befallen the masses' revolutionary potential. In the neo-liberal New World Order of nineties' plenty, political resignation and ideological fatigue, the only thing that can still force the masses to revolt is a hockey game turned sour, and the resulting violence is so cynically aimless and depressingly unmotivated that the viewer almost feels right in thinking the formerly unthinkable. Furthermore one sympathises (or at least empathises) with the forces that wield the State's right to exert violence – namely the police – who, in the equation propounded by *Supernatural*, could be said to be closer to the original Idea of a proletariat than the rowdy crowds of inebriated hooligans who harass and beleaguer them.

The muddled spectacle of white suburban youths running amok in the streets of Vancouver's mildly glitzy downtown core, chanting and bellowing Canucks slogans and telling the Rangers to "go fuck themselves", robbing the contents of shattered shop windows, half-assedly throwing measly bits of trash against any car that happens to pass by, urinating in the personnel entrance of a department store, and, in one especially memorable instance, thumping an unsuspecting camera man in the back, is in fact a ludicrous and almost laughable one. It is exactly what makes this video work such a depressing statement from a merely political point of view; indeed here is where the joke turns sour. There can clearly be no promise of redemption in this sordid display of a particularly crude, retrograde masculinity. It is a vile, testosterone-fuelled scene in which only very few women appear (to bare their breasts, among other activities), and from which the spectre of the Other, that proverbial torch-bearer of Utopia (signified by the "workers" in *Rupture*, "people of colour" in *Abjection*, the "natives" in *Mission*), remains wholly absent. Inevitably, we are reminded of a passage from Theodor Adorno's hugely influential *Aesthetic Theory* that has long been a favourite among Vancouver's well-read community of artists, critics, curators and teachers: "in the ugly, art must denounce the world that creates and reproduces the ugly in its own image".[10] Indeed, this is mankind at its ugliest, man-hood at its lowest ebb.

In *Supernatural*, Arden has reduced the aesthetic intervention to a minimum of indecent exposure: there are no sublime colour fields of a celestial monochrome blue as was the case in *Rupture*, no grand allegorisations or allegories of negation

as in *Abjection*, no theatrical, sanguine reds as in *Mission*, only pitch black darkness in the mere soundless seconds that shackle one scene of despairing lumpen debauchery to another. The work's main critical thrust, in fact, resides in Arden's appropriation of the tightly controlled "Supernatural" nomenclature, a notion that references the British Columbia tourist industry's use of said denomination to peddle the idea of Western Canada's "Lotus Land" to the rest of the world. "Supernatural B.C." is how this promised land of soaring mountain views, overwhelming natural experiences, virgin forest, extreme sports and existential relaxation likes to present itself to Canada and the world, and Arden's deadpan characterisation of the hockey riots as yet another instance of Vancouver's famed daily sublime surely helps to remind us of the price that had to be paid to achieve the mirage of the Dream City's pull on the global imagination.[11] Arden's "natural history of destruction"[12] as a mundane fact of contemporary 'post-political' society may seem nihilistic and defeatist to some, but then again the relentless boosterism that today surrounds the very idea of Vancouver as a desirable global commodity certainly invites the harsh nuances of the artist's scathing take on the inane "Supernatural" brand – even if it means plundering the network archives that usually do such a great job at promoting it.

In *The World as Will and Representation*, Arden's first-ever online project[13], the artist's return to the archival mode is completed in a psychedelic, delirious avalanche of literally thousands of images that occurs like a domino theory of an alternative world history. It is one that encompasses *pace* Arden's unfaltering sense of the microscopic and micropolitical, infinitely more modest and prosaic in tone: a history-telling that brings to mind both the magical view of art as a mode of "othering" (associative, analogous, allegorical, prone to "uncanny juxtapositions", pseudo-scientific, parodic[14]) and the critical theory of art as the melancholy science of "negative dialectics". In appropriating the title of Schopenhauer's morose magnum opus, Arden inevitably subscribes to the bleak world-view that pitted the quarrelsome, cantankerous German philosopher against his contemporary Hegel, whose humourlessly self-confident, optimist belief in the teleology of progress and enlightenment would obviously prove the more influential philosophical doctrine. Schopenhauer's history of the world is a notably gloomy affair and probably closer to the truth than the Hegelian fantasy of History's march into the light. The vision

of inherent stasis and sameness that underlies Schopenhauer's worldview (he was among the first to introduce oriental concepts of circularity into western philosophy, thus questioning the dogma of linearity and teleology that had been shaping western thought since Aristotle[15]) famously presaged the Nietzschean theory of Eternal Recurrence. It also resonates with Arden's caustic vision ("negative diagnostics") of history as an eternal re-run of irresolvable dialectical tensions. The soundtrack to this encyclopaedic project inevitably brings to mind Jorge Luis Borges' famous jibe at the inherent absurdities of the very act of encyclopaedic archiving (quoted in Michel Foucault's *Order of Things*[16]) and is taken from a classic example of righteous, soul-searching sixties Black Music, Timmy Thomas's heartfelt plea "Why Can't We Live Together". In Arden's remix, however, the harrowing lyrics are never allowed to surface, and the song, much like the burning wheel of images it accompanies, remains forever trapped in the organ-pumped circular motion of a choral whose voices fail to materialise. We look on, dumbstruck and oblivious, as history unchains its fearsome powers of forgetting, with the clinical, slightly amused detachment of Arden's diagnostic gaze.

The author would like to acknowledge Roy Arden for the many enlightening and enriching conversations on his work and working methods, on Vancouver and Vancouver art – and art in general. Many thanks also to Monika Szewczyk, who has provided me with indispensable comments and suggestions, and helped me flesh out the argument in this essay.

This is an abridged version of an essay highlighting the pivotal position of Roy Arden in the history of Vancouver's celebrated brand of "post-conceptual photography", and its relationship to that of a highly localised, 'specialist' reading and processing of the teachings of conceptual art from the late sixties onwards.

Notes

1

See, among others: *Roy Arden*, Vancouver: Morris and Helen Belkin Art Gallery & York: Art Gallery of York University, 1997; *Roy Arden: Terminal City*, Salamanca: Ediciones Universidad Salamanca, 1999; *Roy Arden: Selected Works 1985 – 2000*, Oakville: Oakville Galleries, 2002. For obvious reasons, the focus of the current essay is very much on Arden's 'archival' works – the ones that did not directly involve the artist "making pictures" himself.

2

Even though the aestheticisation of the abject – "pretty pictures of miserable matters" – has a history that stretches back to the dawn of Realism (an artistic program that, in itself, holds great significance for Arden), this tactic has taken on a peculiar urgency in Vancouver art, where the dedication to producing images of an exceptional beauty and complexity has helped to establish this particular instance of the dialectical imagination as an 'official' subgenre within the city's arts scene. (Referring to a rather inoffensive Arden picture of a lump of garbage in an East Vancouver gutter, Jeff Wall once remarked: "I've photographed crap lying on the street, too".) A well-established and widely commented line of narration within the existing body of Arden literature, I have chosen to pass over the artist's critical attachment to picturing waste and decay, "the flotsam and jetsam left behind by the tidal waves of History as they wash ashore in the resolutely 'new' outpost of the global economy that is Vancouver." See, among others, my "1,986,965 (2001 Census): An Intertidal Travelogue", in: Roelstraete & Watson (ed.), *Intertidal: Vancouver Art & Artists*, Antwerp: MuHKA & Vancouver: Morris & Helen Belkin Art Gallery, 2005.

3

"Terminal City" is the title of a series of sixteen black and white photographic works (hence, inevitably more 'rustic' than their counterparts in the "Landscape of the Economy" cycle) dating from 1999; 'Terminal City' is also the name given to Vancouver as the endpoint of the Canadian Pacific Railway, an epithet that can signify both the liberating promise of the New that lurks beyond the horizon of the known (i.e. Europe, Eastern Canada), and the 'terminally' dismal abjections and disillusions of a culture that has "reached the end of the line". Always intent on exposing the cracks or 'ruptures' that sully the cosmetically enhanced image of the self-made metropolis – thereby also revealing, ultimately, that metropolis' anchorage in an unsavoury reality – Arden's interest in appropriating this moniker obviously goes out to this City of Loss. For more information, see: Shep Steiner, "Aspects of the Rustic as Trope" in: *Roy Arden: Terminal City*, Salamanca: Ediciones Universidad Salamanca, 1999.

4

Jeff Wall, "An Artist and his Models", published in the catalogue accompanying Arden's solo exhibition at Vancouver's Contemporary Art Gallery in 1993.

5

The work of Sherrie Levine is an especially interesting point of reference in that one of Levine's best-known works, *After Walker Evans* (from 1981), appropriated the canonical imagery of Evans' "journalistic" work of the thirties, which has been referred to in virtually every discussion of Arden's work to date. Jeff Wall in particular has explored Evans' "appropriation of the photojournalistic vernacular in his quest for a modern art photography" in relation to the work of his colleague; see, among others, Jeff Wall & Roy Arden, "The Dignity of the Photograph", in: *ArtPress* n° 251, 1999.

6

Peter Culley, "Out of the Blue: Three Works on Vancouver", in: *BorderCrossings*, May 2001. In his article, Culley expands on the apparent irreconcilability of "the powerfully registered abnegation of *Terminal City*" and the early works in *Fragments*: "manifestly the work of a serious and ambitious young man, the earlier photographs nonetheless revel in a sense of polymorphous delight, with influences unselfconsciously paraded, richly saturated colours enjoyed for their own sake, a joyful urbanity defiantly and enthusiastically invoked". Indeed, whenever "richly saturated colours" are recalled in the later works – the *Wal-Mart Store* photographs perhaps being the most obvious and dramatic examples – the refined 'innocence' of Arden's *Fragments* is but a distant memory; the *frisson* of their freshness still intact when being looked at today, these works' elegiac tone stages an altogether different Vancouver, portrayed, one is tempted to assert, by an altogether different artist.

7

The 1938 riots, culminating in a multitude of embittered, enraged unemployed men occupying Hotel Georgia, the Vancouver Post Office and, ironically, the Vancouver Art Gallery – a most *à propos* comment on the mutual estrangement of the realm of art and that of the "general public" – signalled the end of the Depression, the greatest single instance of socio-economic upheaval in the history of America. The photographs used in *Rupture* invoke memories of Weegee and of the era's greatest chronicler, Walker Evans, whose defining influence was to remain palpable throughout Arden's career. Going back to the derelict, lifeless 'scene' of these riots in the eighties and nineties, now terminally abandoned and emptied out of all vestiges of strife, Arden recorded the ravages of a wholly different kind of 'depression' – one fuelled by lethally cheap drug cocktails and real estate speculation – and appositely grouped these pictures under the *Landscape of the Economy* rubric. The lugubrious, baleful emptiness of Vancouver's Downtown Eastside in this suite conjures the ghost of Eugène Atget's work, another one of the "artist's models" of whom Walter Benjamin famously asserted that his pictures of deserted Parisian streets resembled "scenes of a heinous crime". Finally, Arden's most recent work, the close-up gutter archaeology of *Eureka*, sees the artist return one more time to his 'beloved' back-lots on Hastings and Cordova Street – with a wholly different pictorial agenda.

8

In *Image and Alter-Image II: Roy Arden*, (*Vanguard*, February – March 1987, pp. 24 – 27) Ian Wallace has commented extensively on the artist's ambiguous, polemical coupling of the sky's monochrome blue hue as a time-honed symbol of Utopian deliverance and the defeatist pictorial mémoir of "bloody Sunday", a riot, need-less to say, that was struck down with total disregard for the disgruntled workers' demands; *Rupture* thus dramatizes the dialectic of "History as a document of resistance and defeat" and "Nature as an ahistorical, abstract plenum of transcendence". Following Wallace's reading of *Rupture*, amnesia, despair, indifference and melancholy are the pervading moods and pathologies in Arden's work, of which Jeff Wall later stated that it depicts "local history (…) under the sign of catastrophe" (Jeff Wall, "An Artist and his Models", published in the catalogue accompanying Arden's solo exhibition at Vancouver's Contemporary Art Gallery in 1993).

9

The fourth ensemble of diptychs in the series of archival works mentioned in this essay documents another pivotal moment in Vancouver's thoroughly class- and race-inflected history: the arrival, in 1914, of the passenger ship Komagata Maru, carrying a cargo of Indian immigrants who were denied access to Canada.

10

Theodor Adorno, *Aesthetic Theory*, Minneapolis: University of Minnesota Press, 1998.

11

See Lance Berelowitz, *Dream City: Vancouver and the Global Imagination*, Vancouver: Douglas & MacIntyre, 2005.

12

The reference here is to W. G. Sebald's *On the Natural History of Destruction*, London: Penguin Books, 2004.

13

Viewable on http://www.royarden.com.

14

This is the exact point where Roy Arden's work intersects most markedly with that of fellow Vancouverite Steven Shearer, whose 'archival' works, huge digital prints assembling a dizzying array of photographic images culled from obscure internet sources, deploy a similarly encyclopaedic tactic of "uncanny juxtaposition". Like Arden's archival works, Shearer's archives show artistic thought "at work", caught in the process of its 'other' world-making. In addition, both artists share a singular fascination for the netherworlds of proletarian culture that is clearly not without its biographic overtones. "Arden is the son of Finnish socialists whom emigrated to Canada from a country exhausted by the Second World War, into which his father had been conscripted as a boy soldier… He grew up on a noisy street in a blue-collar neighbour-hood in East Vancouver, just across from industrial sites that lined the banks of the Fraser River"; Nancy Tousley in *Canadian Art*, Summer 2002. Shearer's archives teem with the ignoble emblems of "contemporary proletarian craft" or "blue collar folk culture", most notably of the hard rock/heavy metal variety; Arden's preoccupation with the fate of the proletariat is well-documented, and ranges from the 'historical' *Rupture* series to the more recent *'Locked Out' Workers, Vancouver, B.C.* (1994). Surely, the aforementioned *Supernatural* is another powerful, if bleak, document of "lumpen energy" gone astray; *Basement* (1996) and, especially, *Juggernaut* (2000) also highlight – and with a much more sympathetic inclination – the 'base' materialism of proletarian culture.

15

In Arden's *The World as Will and Representation*, the western creed of linear progress and linearity as such is mercilessly parodied in the *faux-naif* display of alphabetical orderliness in which the artist has accumulated his visual loot, most of which is of a rather underwhelming, neutral or indifferent nature. As a matter of principle, there are no real artworks in Arden's digital archive-gone-berserk.

Pictures of "Altamont" – the Stones concert in 1969 which signalled the demise of the sixties acid trip of love, peace and happiness – are followed by photographs of household objects in "Aluminum", of the "American Taliban" John Walker, of "Apes, Planet of", "Armour", "Asphalt" and so on – *ad nauseam* indeed. This humbling travesty of classification and taxonomy also relates back to art's critique of the hegemonic *epistemè* of scientific thought, with its relentless insistence on making the world a transparent and wholly surveyable place – another tyrannical hallmark of western 'ocularcentrist' discourse.

16

Borges (as quoted by Foucault) in turn quotes the example of a certain Chinese encyclopaedia which grouped "animals" as follows: "a) animals which belong to the emperor, b) embalmed animals, c) tamed animals, d) milk sows, e) sirens, f) fabulous beasts, g) dogs without a master, h) those which belong into this grouping, i) those who behave like mad, k) animals painted with a very fine brush of camel hair, l) and so forth, m) animals which have broken the water jug, n) animals which look like flies from afar." See Michel Foucault, *The Order of Things: An Archaelogy of Human Sciences*, New York: Vintage, 1994.

Abjection 1985

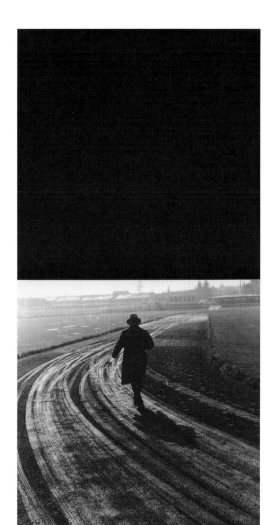

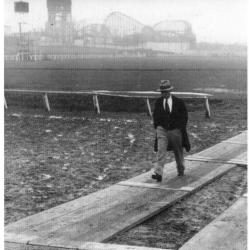
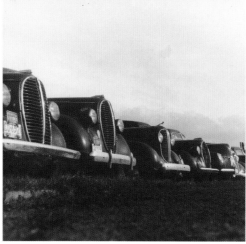
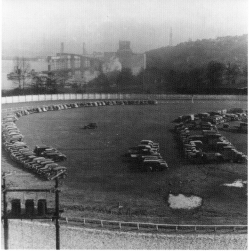

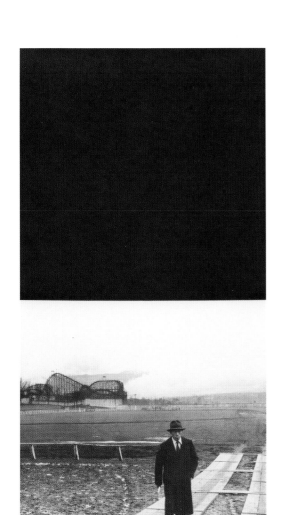

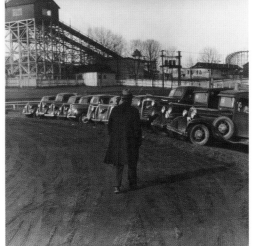

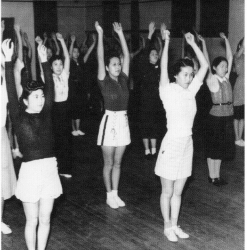

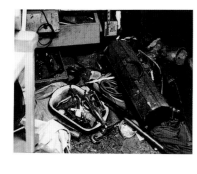
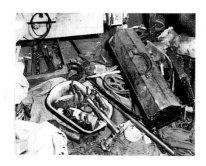
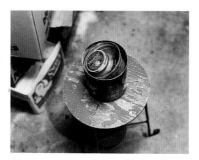

Basement 1996

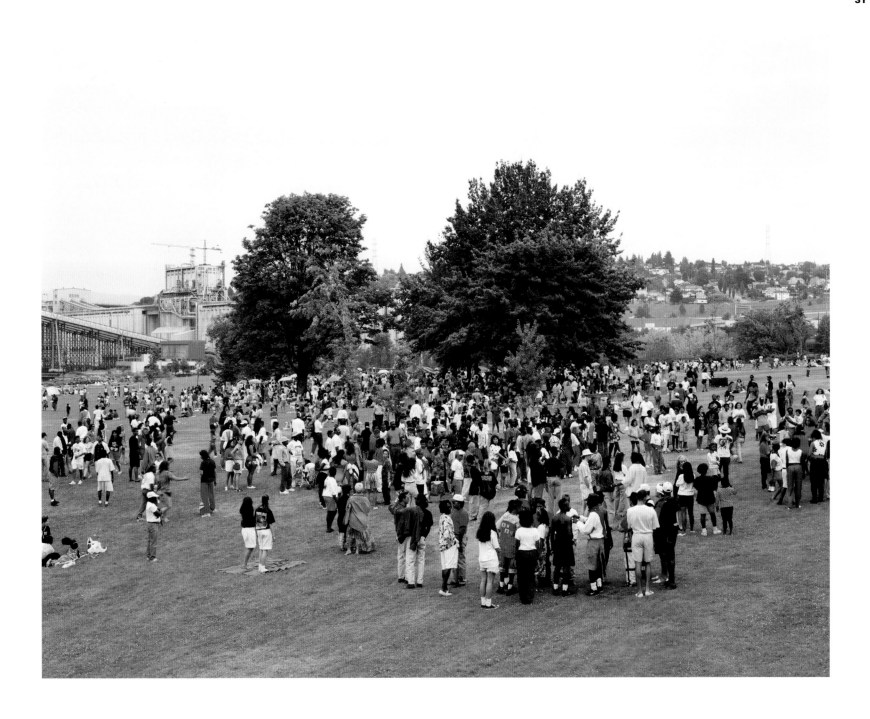

Caribbean Festival, Vancouver, B.C. 1992

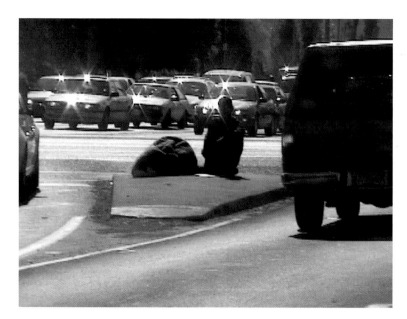
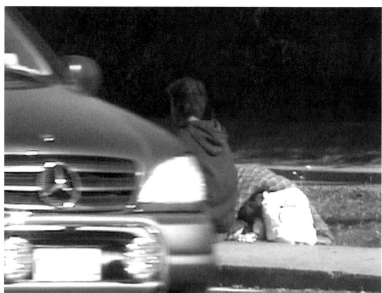
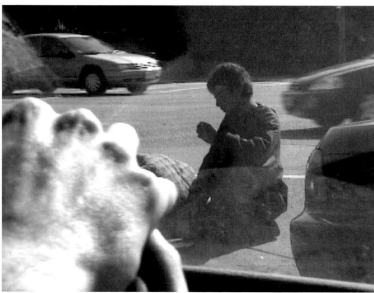
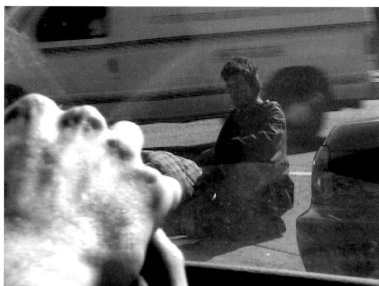

Citizen 2000

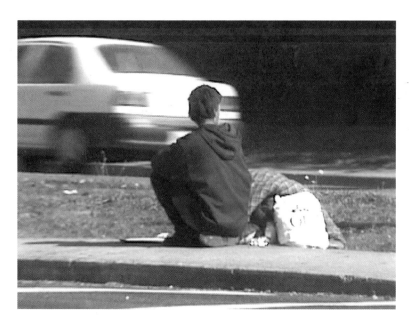

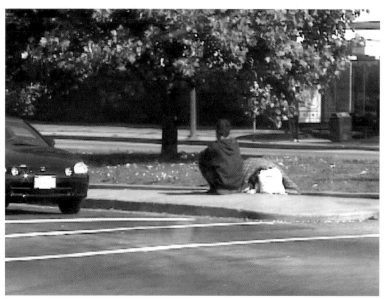

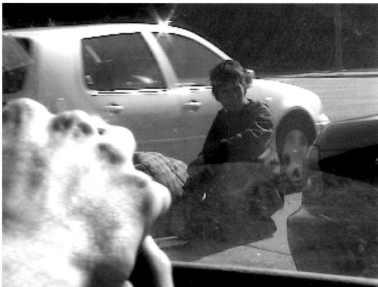

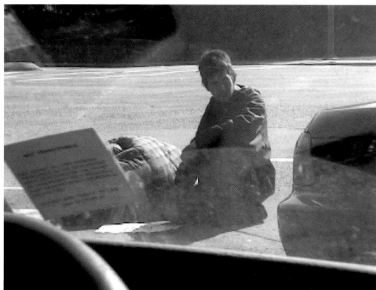

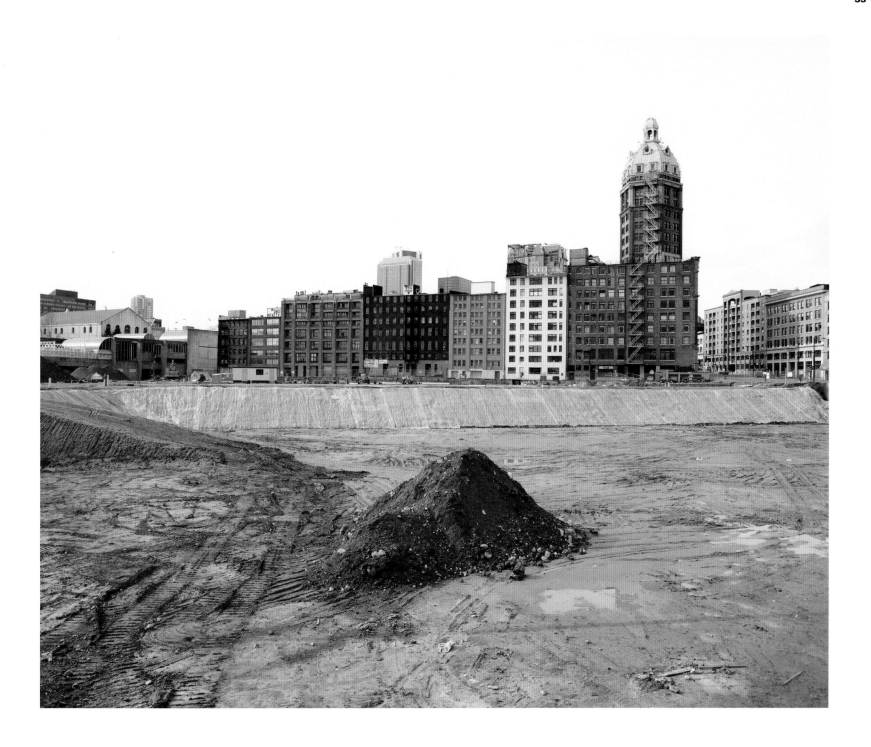

Construction Site and Suntower, Vancouver, B.C. 1992

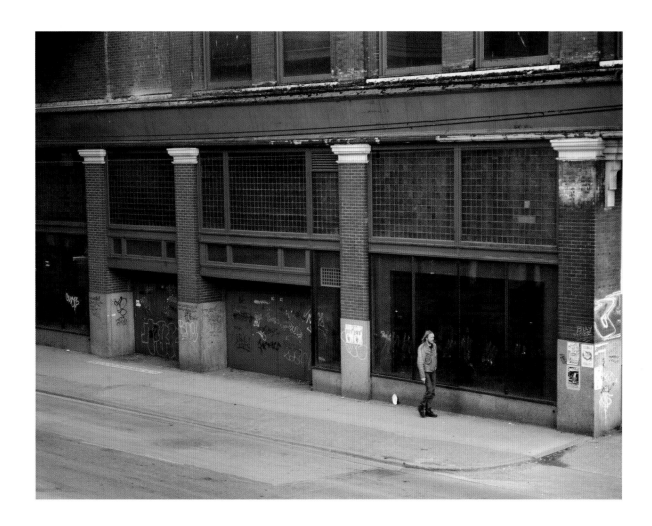

Cordova Street, Vancouver, B.C. 1995

Crow 2002

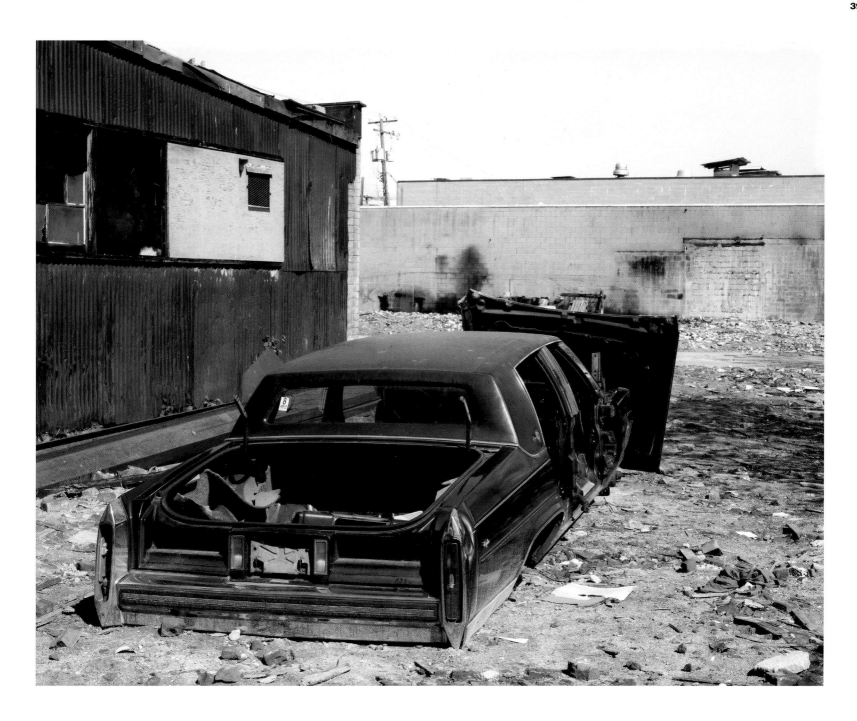

d'Elegance (#1) 2000

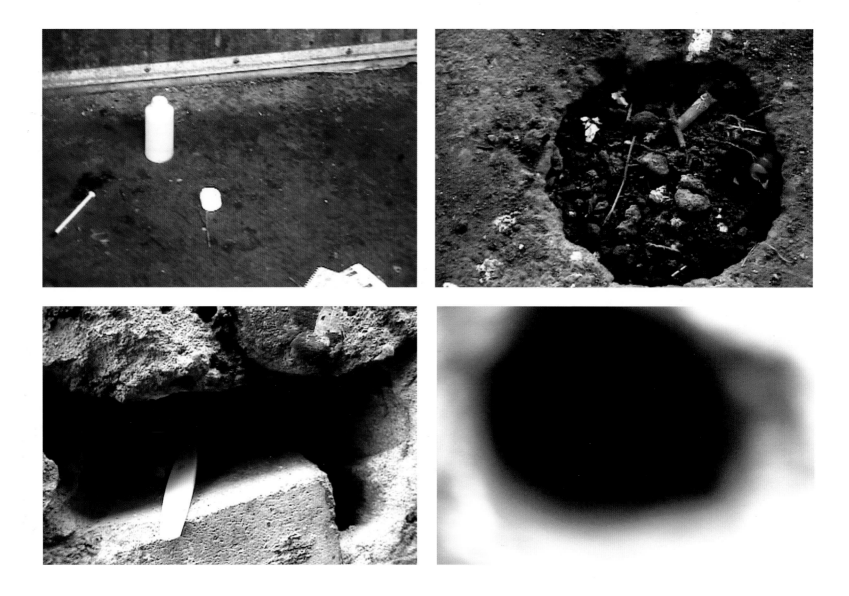

Eureka 2005

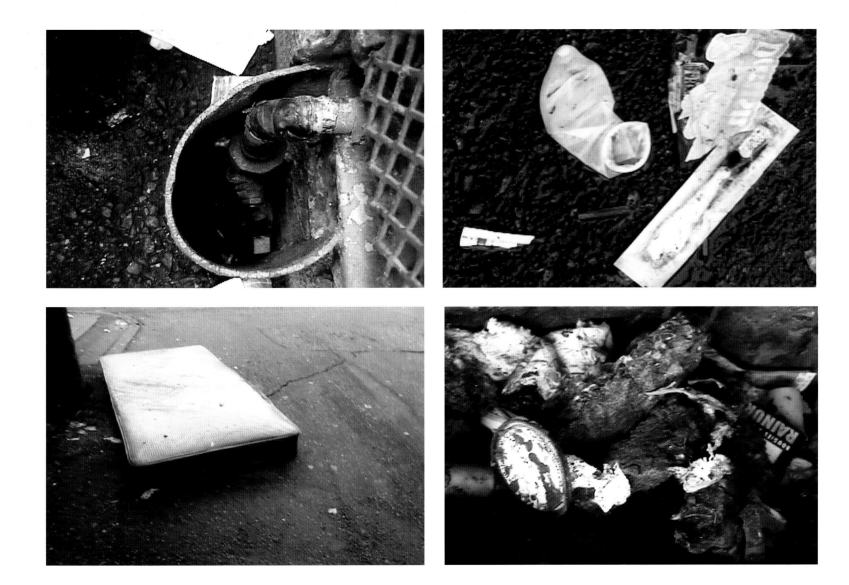

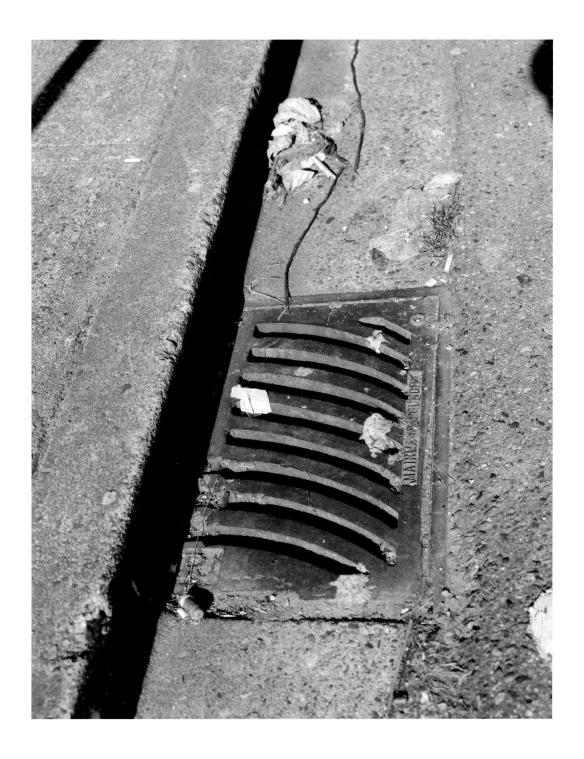

Gutter with Rags #2 2000

Hastings Street Sidewalk, Vancouver, B.C. 1995

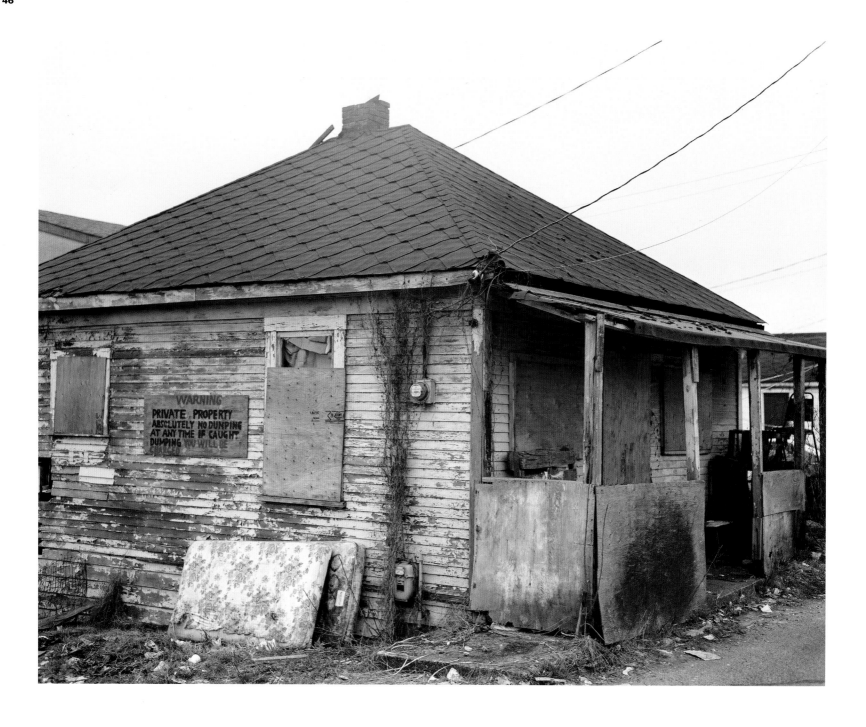

House in Strathcona Alley, Vancouver, B.C. 1995

Juggernaut 2000

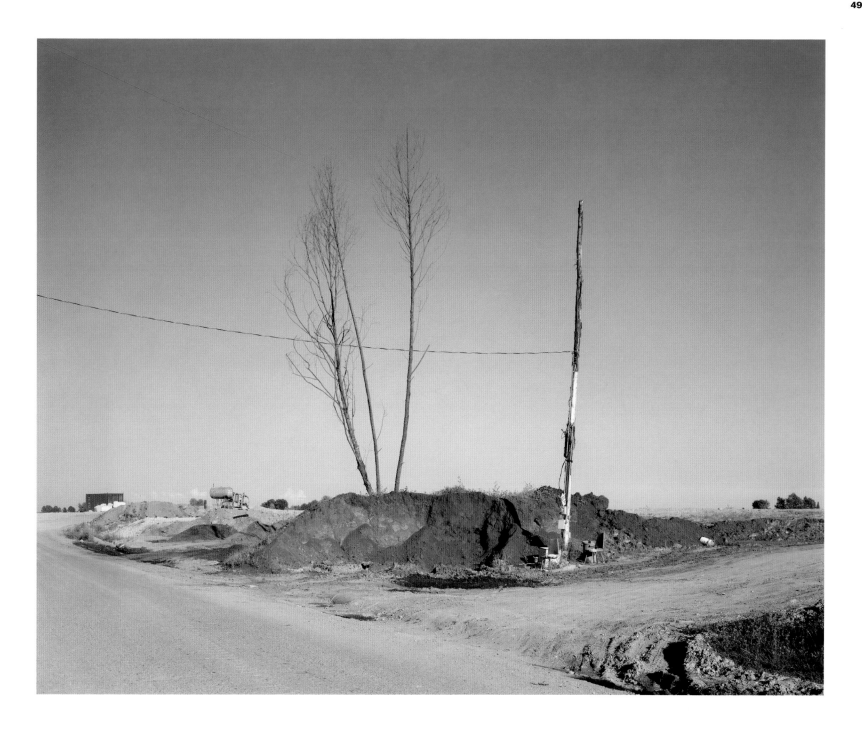

Landfill, Richmond, B.C. 1991

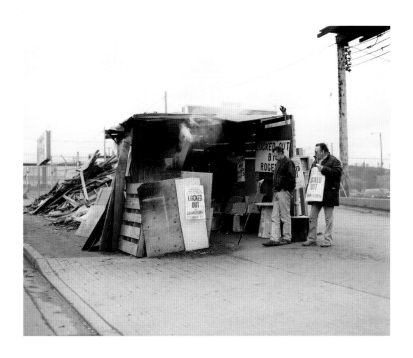

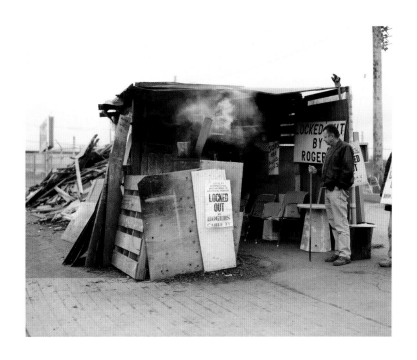

Locked Out Workers, Vancouver, B.C. 1994

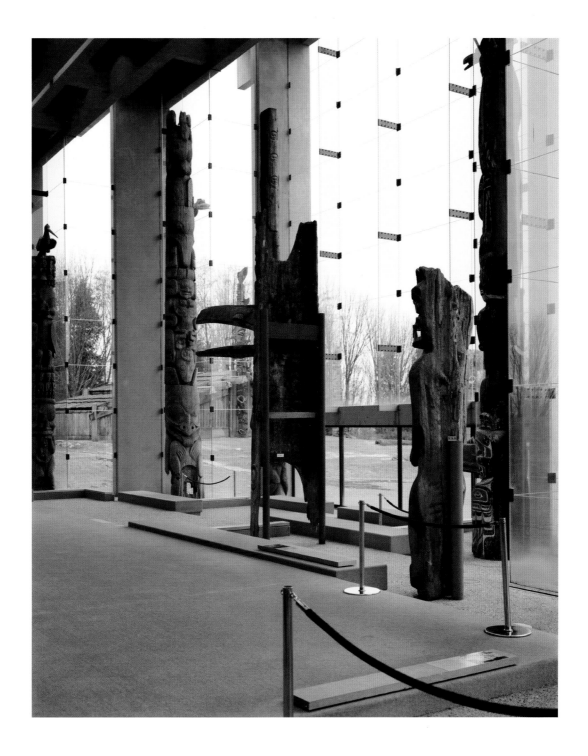

Museum of Anthropology, U.B.C., Vancouver, B.C. #5 1991

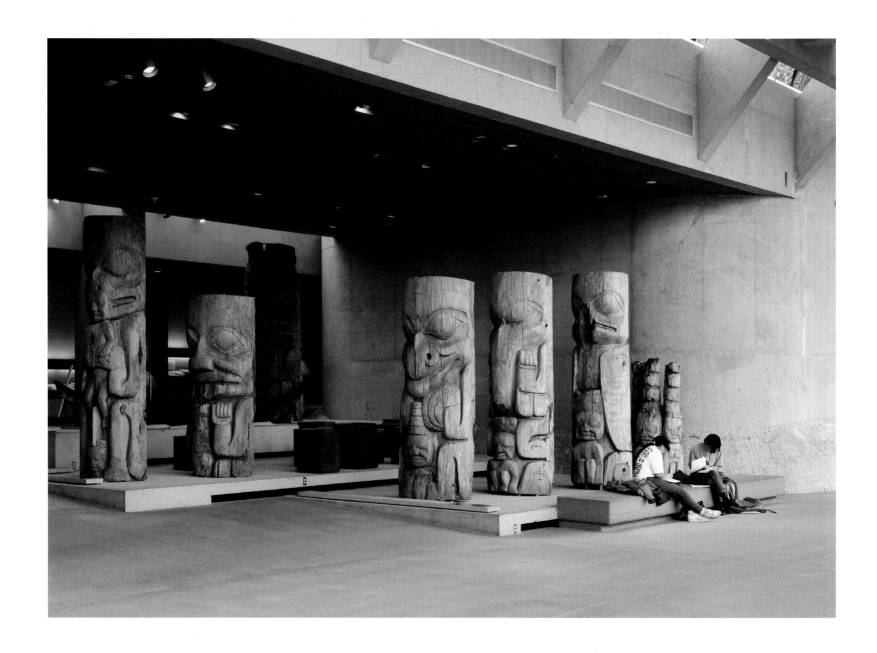

Museum of Anthropology, U.B.C., Vancouver, B.C. #3 1991

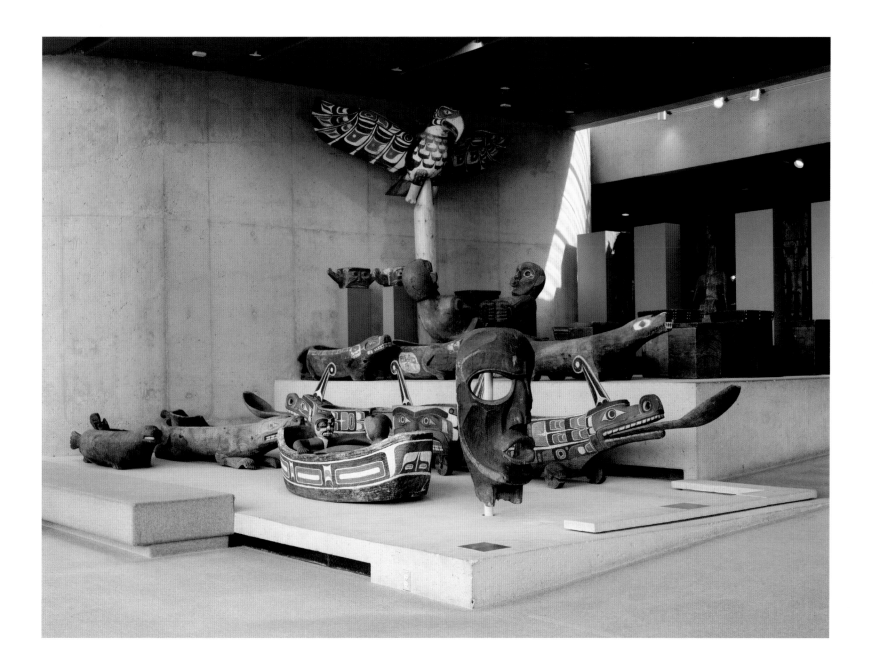

Museum of Anthropology, U.B.C., Vancouver, B.C. #2 1991

Museum of Anthropology, U.B.C., Vancouver, B.C. #1 1991

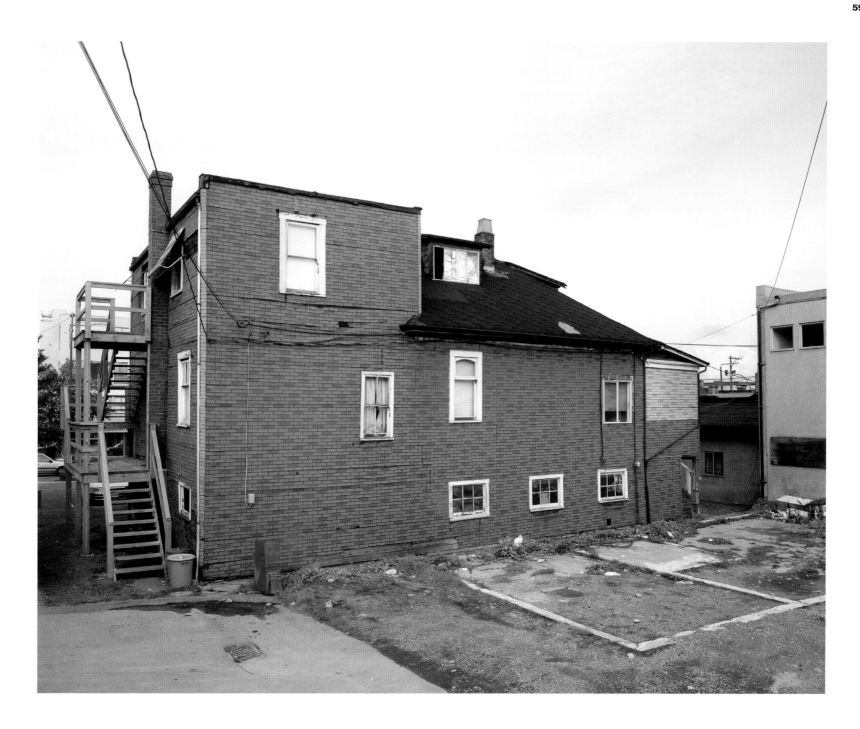

Ochre Boarding House 1997

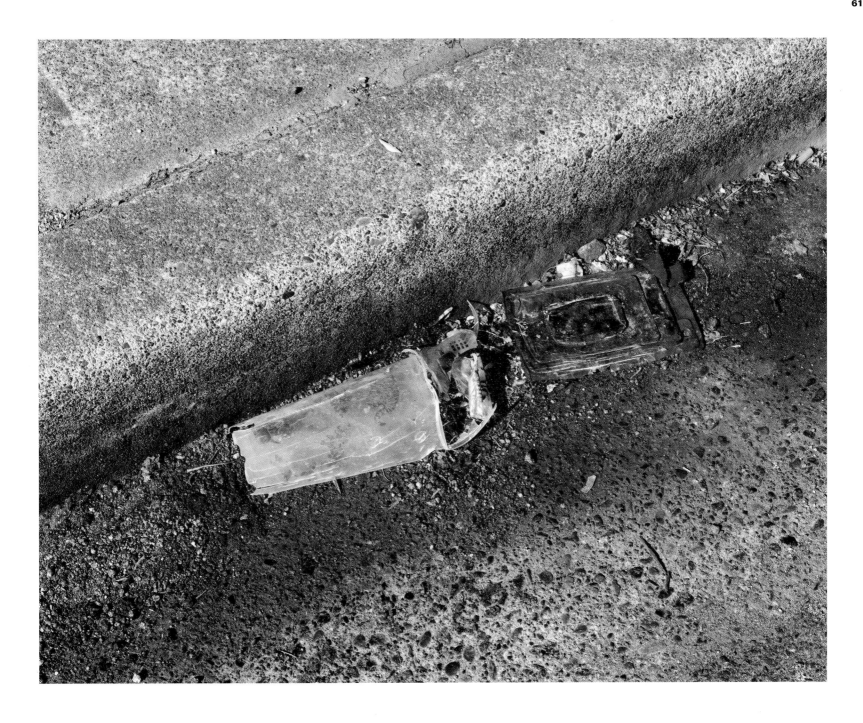

Plastic 2002

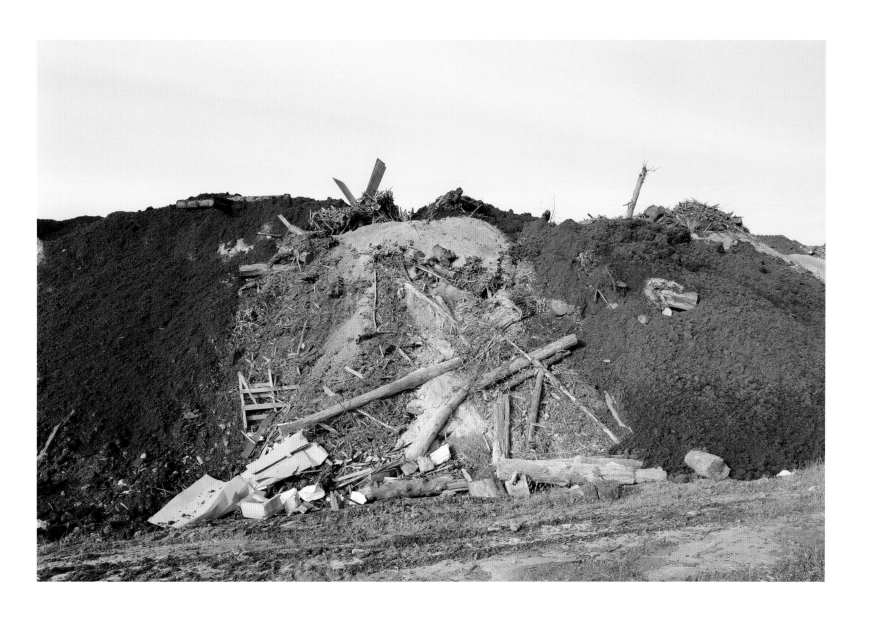

Pulp Mill Dump (#1), Nanaimo, B.C. 1992

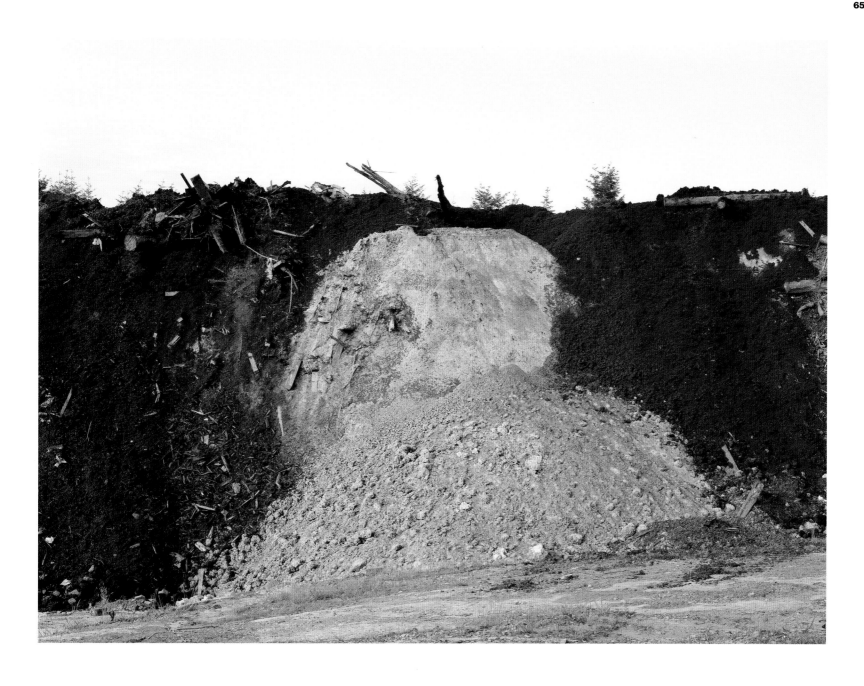

Pulp Mill Dump (#2), Nanaimo, B.C. 1992

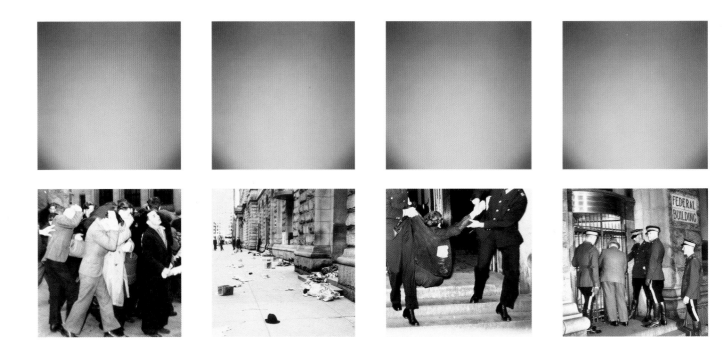

Rupture 1985

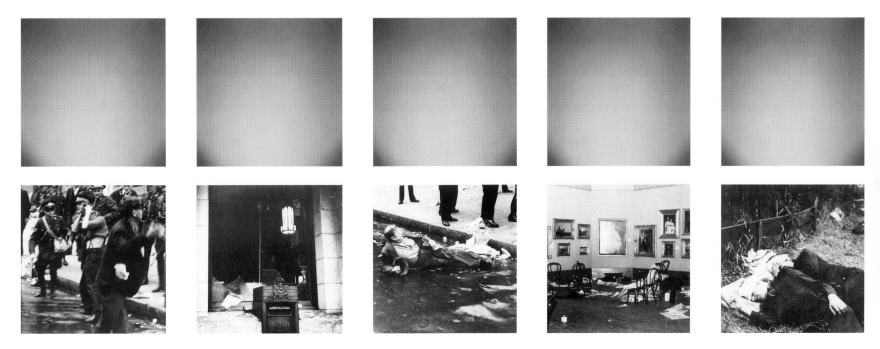

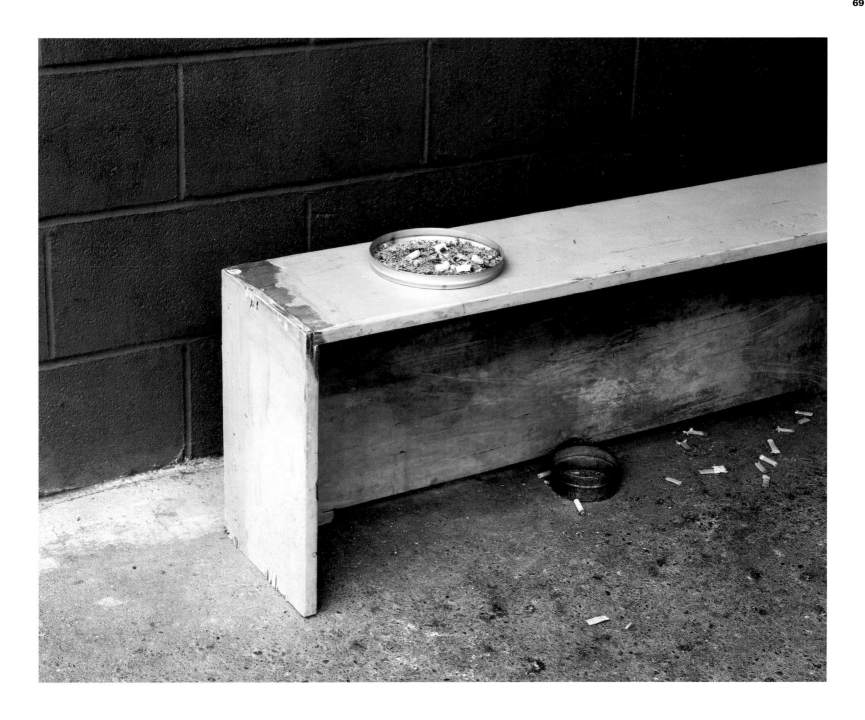

Smoking Area 2002

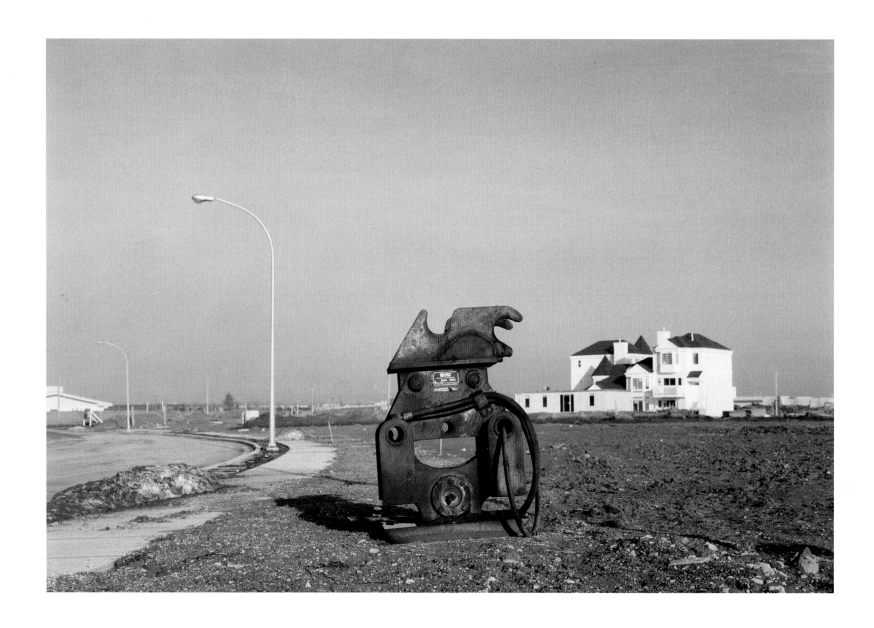

Soil Compactor, Richmond, B.C. 1992

South Vancouver (#1) 1997

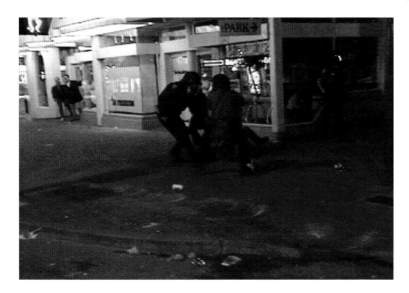
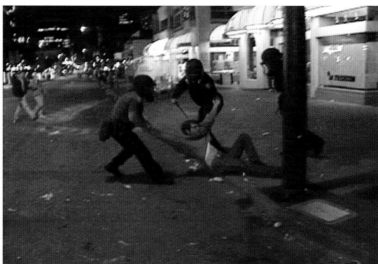
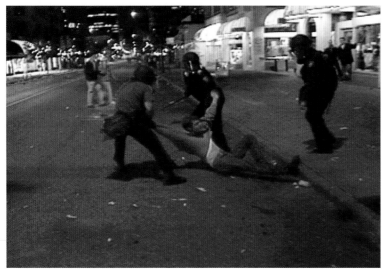
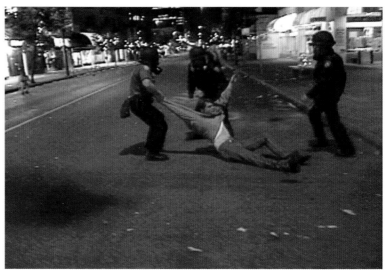

Supernatural 2005

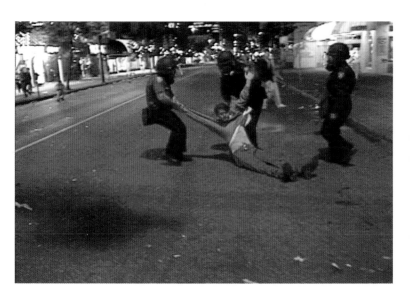
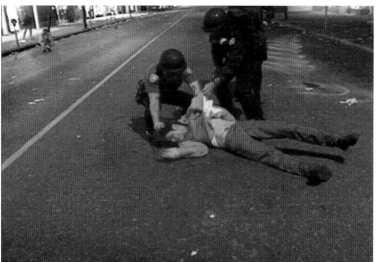
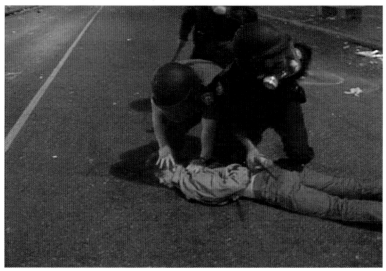
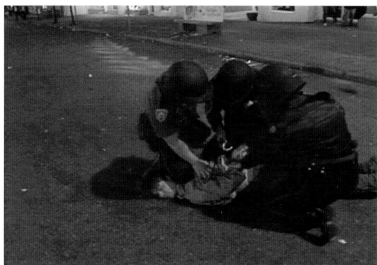

List of Works in Exhibition

Abjection 1985
Ten diptych panels: gelatin silver prints and exposed photo paper
81.2 x 40.6 cm (each)
Collection: Jeff Wall, Vancouver

Basement 1996
10 gelatin silver and 10 C print photographs
Each: 50.8 x 61 cm, framed
Collection: Wilhelm Schürmann, Aachen

Caribbean Festival, Vancouver, B.C. 1992
Archival pigment print
104.1 x 139.7 cm, framed
Courtesy: The artist and Monte Clark Gallery, Vancouver and Toronto

Citizen 2000
Video DVD for projection, colour, sound
Courtesy: The artist and Monte Clark Gallery, Vancouver and Toronto

Construction Site and Suntower, Vancouver, B.C. 1992
Archival pigment print
106 x 130.3 cm, framed
Courtesy: The artist and Monte Clark Gallery, Vancouver and Toronto

Cordova Street, Vancouver, B.C. 1995
C print
12.5 x 16 cm, image size
Courtesy: The artist and Galerie Tanit, Munich

Crow 2002
Gelatin silver print
71 x 88.9 cm, image size
Courtesy: The artist and Monte Clark Gallery, Vancouver and Toronto

d'Elegance (#1) 2000
Gelatin silver print
101 x 127 cm, image size
Courtesy: The artist and Monte Clark Gallery, Vancouver and Toronto

Eureka 2005
Video DVD for monitor display, colour, sound
Courtesy: The artist and Monte Clark Gallery, Vancouver and Toronto

Gutter with Rags #2 2000
Gelatin silver print
72.4 x 57.8 cm, image size
Courtesy: The artist and Monte Clark Gallery, Vancouver and Toronto

Hastings Street Sidewalk, Vancouver, B.C. 1995
C print
12.5 x 16 cm, image size
Courtesy: The artist and Galerie Tanit, Munich

House in Strathcona Alley, Vancouver, B.C. 1995
Transmounted C print
104.1 x 129.5 cm, framed
Courtesy: The artist and Galerie Tanit, Munich

Juggernaut 2000
Video DVD for monitor display, colour, sound
Courtesy: The artist and Monte Clark Gallery, Vancouver and Toronto

Landfill, Richmond, B.C. 1991
C print
104.1 x 129.5 cm, framed
Collection: Jeremy Caddy, Vancouver

Locked Out Workers, Vancouver, B.C. 1994
Transmounted C print
106.7 x 81.3 cm, framed
Courtesy: The artist and Galerie Tanit, Munich

'Monster House' Coquitlam, B.C. 1996
Transmounted C print
106.2 x 125.8 cm, framed
Collection: Canadian Museum of Contemporary Photography, an affiliate of the National Gallery of Canada, Ottawa

Museum of Anthropology, U.B.C., Vancouver, B.C. #1 1991
Archival pigment print
106 x 130.3 cm, framed
Courtesy: The artist and Monte Clark Gallery, Vancouver and Toronto

Museum of Anthropology, U.B.C., Vancouver, B.C. #2 1991
Archival pigment print
106 x 130.3 cm, framed
Courtesy: The artist and Monte Clark Gallery, Vancouver and Toronto

Museum of Anthropology, U.B.C.,
Vancouver, B.C. #3 1991
Archival pigment print
106 x 130.3 cm, framed
Courtesy: The artist and Monte Clark
Gallery, Vancouver and Toronto

Museum of Anthropology, U.B.C.,
Vancouver, B.C. #5 1991
Archival pigment print
106 x 130.3 cm, framed
Courtesy: The artist and Monte Clark
Gallery, Vancouver and Toronto

Ochre Boarding House 1997
Transmounted C print
104.1 x 139.7 cm, framed
Courtesy: The artist and Galerie Tanit, Munich

Plastic 2002
Gelatin silver print
47 x 59 cm, image size
Courtesy: The artist and Monte Clark
Gallery, Vancouver and Toronto

Pulp Mill Dump (#1), Nanaimo, B.C. 1992
Transmounted C print
104.1 x 139.7 cm, framed
Collection: Oakville Galleries, Oakville,
Ontario

Pulp Mill Dump (#2), Nanaimo, B.C. 1992
Transmounted C print
104.1 x 139.7 cm, framed
Collection: Oakville Galleries, Oakville,
Ontario

Rupture 1985
Nine diptych panels; cibachrome and gelatin
silver prints on paper
71.5 x 43.5 cm (each)
Courtesy: The artist and Monte Clark Gallery,
Vancouver and Toronto

Smoking Area 2002
Gelatin silver print
76.2 x 96.5 image size
Courtesy: The artist and Monte Clark
Gallery, Vancouver and Toronto

Soil Compactor, Richmond, B.C. 1992
Giclee on paper
105.4 x 145 cm, framed
Collection: Vancouver Art Gallery Acquisition
Fund, Gift of Claudia Beck and Andrew
Gruft, Vancouver

South Vancouver (#1) 1997
Transmounted C print
102 x 122 cm, framed
Courtesy: The artist and Galerie Tanit,
Munich

Supernatural 2005
Video DVD for projection, colour, sound
Courtesy: The artist and Monte Clark
Gallery, Vancouver and Toronto

Terminal City (#1–16) 1999
Suite of 16 gelatin silver prints
59.8 x 64 cm each, framed
Collection: Vancouver Art Gallery
Acquisition Fund

Tree Stump, Nanaimo, B.C. 1991
Transmounted C print
106 x 130.3 cm, framed
Collection: Canadian Museum of
Contemporary Photography, an affiliate
of the National Gallery of Canada, Ottawa

Wal-Mart Store (Applejacks), Burnaby, B.C.
1996
Archival pigment print
106 x 130.3 cm, framed
Courtesy: The artist and Monte Clark
Gallery, Vancouver and Toronto

Wal-Mart Store (Tide), Burnaby, B.C.
1996
Archival pigment print
106 x 130.3 cm, framed
Courtesy: The artist and Monte Clark
Gallery, Vancouver and Toronto

Biography

Born: Vancouver, 1957
Emily Carr College of Art & Design,
Diploma, 1982
University of British Columbia, Master of
Fine Arts, 1990

Solo Exhibitions

2006
Roy Arden, Ikon Gallery, Birmingham
(catalogue)
Against the Day, Richard Telles Gallery,
Los Angeles

2005
Roy Arden – Fragments, Galerie Tanit,
Munich

2004
Fragments – photographs 1981–85,
Monte Clark Gallery, Toronto
Citizen, Ikon Gallery, Birmingham
Monster House, Monte Clark Gallery,
Vancouver

2002
Video, Belkin Satellite, Vancouver
Photographs, Monte Clark Gallery, Vancouver
Photographs, Monte Clark Gallery, Toronto
Selected Works 1985–2000, Oakville
Galleries, Oakville, Ontario,
(catalogue)
Selected Works 1985–2000, Vox,
Montréal (catalogue)
Fragments – photographs 1981–85,

Oakville Galleries, Oakville, Ontario,
(catalogue)

2001
Dee/Glasoe, New York
Gilles Peyroulet & cie., Paris
L'Aquarium, galerie d'école, Valenciennes

2000
Gilles Peyroulet & cie., Paris
Patrick Painter Inc., Santa Monica
Terminal City Monte Clark Gallery,
Vancouver
Fragments – Photographs 1981–85,
Presentation House Gallery, North
Vancouver (catalogue)

1999
Terminal City, Centro de Fotografia,
Universidad de Salamanca, Salamanca

1998
Illingworth Kerr Gallery, Alberta College of
Art and Design Calgary, (catalogue)
Patrick Painter, Inc., Santa Monica

1997
Art Gallery of York University, Toronto
(catalogue)
Morris and Helen Belkin Gallery, University
of British Columbia, Vancouver (catalogue)

1996
American Fine Arts Co., New York

1993
Contemporary Art Gallery, Vancouver
(catalogue)

1990
Galerie Giovanna Minelli, Paris
OR Gallery, Vancouver
Services Culturels de L'Ambassade du
Canada, Paris

1989
Hippolyte Gallery, Helsinki
OR Gallery, Vancouver

1988
West, Artspeak, Vancouver (catalogue)

1987
YYZ Artists Outlet, Toronto
Dazibao, Montreal

1986
Mission/Black Sun, Western Front Gallery,
Vancouver

1985
Fragments, Halle Sud, Geneva
Rupture, OR Gallery, Vancouver
Abjection, Coburg Gallery, Vancouver

1983
Fragments, Coburg Gallery, Vancouver
Photographs, OR Gallery, Vancouver

Group Exhibitions

2005
Covering the Real – Art and the Press Picture from Warhol to Tillmans, Kunstmuseum Basel (catalogue)
Roy Arden, Michael Krebber, John Miller, Richard Telles Gallery, Los Angeles
Real Pictures – Photographs from the Collection of Claudia Beck and Andrew Gruft, Vancouver Art Gallery (catalogue)
Classified Materials-Accumulations, Archives, Artists, Vancouver Art Gallery
Citizens, Art Circuit Touring Exhibitions, London – Pitzhanger Manor Museum, London; The City Gallery, Leicester; Oriel Davies, Powys, Wales; The Ormeau Baths, Belfast; Pinacotheque São Paulo

2004
Jede Fotografie ein Bild – Siemens Fotosammlung
Pinakothek der Moderne, Munich (catalogue)
Busan Biennale, Busan, Korea (catalogue)
Likeness – Portraits of Artists by other Artists, CCA Wattis Institute for Contemporary Arts, San Francisco (catalogue)
Future Cities, Art Gallery of Hamilton, Hamilton, Ontario (catalogue)
Nowhere Home, Art Gallery of Ontario
Paysages Invisibles, Musee departmental d'art contemporain de Rochechouart.
Mouvements de fonds, MAC – galleries contemporaines des musée de Marseille, Marseille
The Shadow of Production, Vancouver Art Gallery

2003
À mains nues, Frac Haute-Normandie, Sotteville-les Rouen
Paradise Lost, Monte Clark Gallery, Toronto
Various Properties, Morris and Helen Belkin Gallery, University of British Columbia, Vancouver
Supermarché, Gilles Peyroulet & cie., Paris
A Proposal for an Exhibition (curated by Claudia Beck and Andrew Gruft) Monte Clark Gallery, Toronto
Boarding Pass, Monte Clark Gallery, Toronto

2002
A Proposal for an Exhibition (curated by Claudia Beck and Andrew Gruft) Monte Clark Gallery, Vancouver
Shopping – Art & Consumer Culture, Tate Liverpool; Schirn Kunsthalle, Frankfurt (catalogue)
Politics, Gilles Peyroulet & cie., Paris
Prophets of Boom – Werke aus der Sammlung Schürmann, Staatliche Kunsthalle Baden-Baden
Citizen, Gilles Peyroulet & cie., Paris
This Place, Vancouver Art Gallery
Mouvements de fonds Acquisitions 2002 du Fonds national d'art contemporain, Centre de la Vieille charité, Marseille

2001
Roy Arden / Scott McFarland / Howard Ursuliak / Stephen Waddell / Jeff Wall, Monte Clark Gallery, Toronto
Pictures, Positions and Places, Vancouver Art Gallery

Surprises, Gilles Peyroulet & cie., Paris
Superman in Bed, Kunst der Gegenwart und Fotografie (Sammlung Schürmann), Museum am Ostwald, Dortmund
Urban Landscapes, Gilles Peyroulet & cie., Paris
Processo Documentals, Museu d'Art Contemporani de Barcelona
Commandes photographiques du Groupe Lhoist: Roy Arden, Bernd et Hilla Becher, Elliot Erwitt, Rodney Graham, Jan Henle, Josef Koudelka, Centre national de la photographie, Paris
Vancouver Collects, Vancouver Art Gallery (catalogue)
Imagining Places and Travelling Spaces, MacKenzie Art Gallery, Regina

2000
Deep Distance, Kunsthalle Basel (catalogue)
The City, Nicole Klagsbrun, New York
Contaminated Symptoms, Oakville Galleries, Oakville
Image & Light, History and Influence, Charles H. Scott Gallery, Vancouver
Out of This Century, Vancouver Art Gallery

1999
Views from the Edge of the World, Marlborough Chelsea, New York
Objects In The Rear View Mirror May Appear Closer Than They Are, Galerie Max Hetzler, Berlin
Nanaimo B.C. to National City CA, Portland Art Museum

1998
Everyday, 11th Biennale of Sydney, Sydney (catalogue)
Entropie Zu Hause, Suermondt Ludwig Museum, Aachen
A Sense of Place, Angles Gallery, Los Angeles
New Works: Roy Arden, Glenn Brown, Roni Horn, Mike Kelley, Mark Lewis, Paul McCarthy, Jorge Pardo, Diana Thater, Patrick Painter, Inc., Santa Monica

1997
Tableaux, Vaknin Schwartz Gallery, Atlanta
Panique Au Faubourg, Quartiere Ephémère, Montreal
Landmarks, John Weber, New York
Track Records, Canadian Centre for Contemporary Photography (catalogue)

1996
Roy Arden/Dan Graham/Ed Ruscha/ Christopher Williams, Blum & Poe, Los Angeles
The Culture of Nature, Kamloops Art Gallery, BC
d'une main…l'autre, Galerie Municipale du Chateau d'Eau, Toulouse, France

1995
The Friendly Village, Milwaukee Institute of Art & Design (catalogue)
Roy Arden/Gaylen Gerber, American Fine Arts Co., New York
Roy Arden/Paul McCarthy/Richard Prince/ Juan Munoz, Jack Hanley Gallery, San Francisco

1994
Roy Arden/Candida Hofer, Nicole Klagsbrun Gallery, New York
In the Field, Landscape in Recent Photography, Margo Leavin Gallery, Los Angeles

1993
Canada, Une nouvelle génération, Musee Municipal de La Roche-sur-Yon, and Musee des Beaux-Arts et FRAC Franche-Comte, Dole, France (catalogue)
Patrick Painter Editions, Galerie Johnen & Schottle, Cologne
Beneath the Paving Stones, Charles H. Scott Gallery, Vancouver (catalogue)

1992
Huitiemes Ateliers Internationaux, Pays de la Loire, Garenne Lemot, Clisson, France (catalogue)

1991
Peuples En Image: Weegee, Bill Henson, Roy Arden, Raymonde April and AnneFavrat, Le Lieu Galerie de Photographies, Lorient, France
VAN – 7 Vancouver Artists, Wilkey Fine Arts, Seattle
Dismember, Museum of Traditional Values – Simon Watson, New York

1990
Fotographie Biennale Rotterdam, Perspektief (catalogue)
Prive/Public – Art et Discours Social, La Galerie dart Essai and La Galerie du Cloitre, Rennes and Winnipeg Art Gallery (catalogue)
150 ans de Photographie, Musee des beaux arts, Nantes

1989
Taking Pictures, Presentation House Gallery, North Vancouver (catalogue)
Perspective 89 – Roy Arden and Dominique Blain, Art Gallery of Ontario, Toronto (catalogue)
Photo Kunst, Staatsgalerie, Stuttgart (catalogue)
Selections from the Ann & Marshall Webb Collection
Art Gallery of York University, Toronto

1988
The Discursive Field of Recent Photography, Artculture Resources Centre, Toronto (catalogue)
Behind the Sign, (in collaboration with Jeff Derksen), Artspeak, Vancouver (catalogue)
Made in Camera, Galleri Sten Eriksson, VAVD, Stockholm (catalogue)

1987
Roy Arden and Janice Gurney, Coburg Gallery, Vancouver
Reconnaissance – Vikky Alexander, Roy Arden, Jamelie Hassan, Walter Phillips Gallery, Banff, Alberta

1986

Three Points, Twelve Views, Surrey Art
Gallery, Seattle Art Museum, Portland Art
Museum (catalogue)
*Making History – Recent Art of the Pacific
West*, Vancouver Art Gallery
Wordworks, 911 Gallery, Seattle
Broken Muse, Vancouver Art Gallery
(catalogue)
Camera Works, OR Gallery, Vancouver

1984

Art and Photography, Vancouver Art Gallery
(catalogue)

1983

Vancouver: Art and Artists 1931 – 1983,
Vancouver Art Gallery (catalogue)

1979

Twenty Photo Artists, Pumps Gallery,
Vancouver (catalogue)

Collections

Art Gallery of Ontario, Toronto
Caisse des Dépôt et consignations, Paris
Canada Council Art Bank, Ottawa
DG Bank, Frankfurt
Fond national d'art contemporain, Paris
F.R.A.C., Pays de la Loire, Nantes
Fondacion C.O.F.F., San Sebastian, Spain
Los Angeles County Museum of Art,
 Los Angeles
Mackenzie Art Gallery, Regina
Metropolitan Bank & Trust Collection,
 Cleveland, Ohio
Morris and Helen Belkin Art Gallery,
 University of British Columbia, Vancouver
Morris J. Wosk Centre for Dialogue,
 Simon Fraser University, Vancouver
Musée d'art contemporain, Geneva
Musée d'art contemporain de Montréal
Musée national d'art moderne, Paris
Museum of Modern Art, New York
Oakville Galleries, Oakville, Ontario
Siemens Fotosammlung, Pinakothek der
 Moderne, Munich
Staatsgalerie, Stuttgart
Vancouver Art Gallery
Walter Phillips Gallery, Banff, Alberta
Winnipeg Art Gallery
Ydessa Hendeles Art Foundation, Toronto

Roy Arden

Ikon Gallery, Birmingham
1 February – 19 March 2006

Exhibition curated by Nigel Prince

ISBN 1 904864 17 1

Ikon Gallery
1 Oozells Square, Brindleyplace, Birmingham, B1 2HS
t: +44 (0) 121 248 0708 f: +44 (0) 121 248 0709
http://www.ikon-gallery.co.uk
Registered charity no: 528892

Edited by Nigel Prince
Designed by Herman Lelie and Stefania Bonelli
Printed by Dexter Graphics

All photography and scans by Roy Arden except *Abjection* courtesy
of Pinakothek der Moderne, Bayerische Staatsgemäldesammlungen

Distributed by Cornerhouse Publications
70 Oxford Street, Manchester, M1 5NH
t: +44 (0)161 200 1503 f: +44 (0)161 200 1504
publications@cornerhouse.org

Ikon Staff
Arsha Arshad, Visitor Assistant; *Simon Bloor*, Visitor Assistant; *Mike
Buckle*, Assistant – Ikon Shop; *James Cangiano*, Education Coordinator
(Maternity Cover); *Rosalind Case*, PA/Office Manager; *James Eaves*,
Fundraising Manager; *Siân Evans*, Programme Assistant; *Richard
George*, Manager – Ikon Shop; *Graham Halstead*, Deputy Director;
Matthew Hogan, Facilities Technician (AV/IT); *Saira Holmes*, Curator
(Education and Interpretation); *Deborah Kermode*, Curator (Off-site);
Helen Legg, Curator (Off-site); *Emily Luxford*, Marketing Assistant;
Chris Maggs, Facilities Technician; *Deborah Manning*, Visitor Assistant;
Jacklyn McDonald, Visitor Assistant; *Natalia Morris*, Visitor Assistant;
Michelle Munn, Visitor Assistant; *Esther Nightingale*, Education
Coordinator (Creative Partnerships); *Matt Nightingale*, Gallery Facilities
Manager; *Melissa Nisbett*, Marketing Manager; *Jigisha Patel*, PR and
Press Manager; *Nigel Prince*, Curator (Gallery); *Theresa Radcliffe*,
Gallery Assistant; *Kate Self,* Gallery Assistant; *Nikki Shaw*, Education
Coordinator; *Richard Short*, Technical and Office Assistant; *Diana
Stevenson*, Exhibitions Coordinator; *Dianne Tanner*, Finance Manager;
Jonathan Watkins, Director; *Leon Yearwood*, Visitor Assistant

Roy Arden and Ikon would like to thank Richard Rhodes, Editor of
Canadian Art for permission to reprint the revised version of the
original article by Nancy Tousley.

Ikon gratefully acknowledges financial assistance from Arts Council England, West Midlands and Birmingham City Council.

This exhibition is supported by the Canadian High Commission and Department of Foreign Affairs and International Trade, Canada
with aid from Vancouver Art Gallery